IMAGES
of America

EARLY PHOENIX

IMAGES
of America

EARLY PHOENIX

Kathleen Garcia

ARCADIA
PUBLISHING

Published by Arcadia Publishing
Charleston, South Carolina

Printed in the United States of America

Library of Congress Catalog Card Number: 2007935837

For all general information contact Arcadia Publishing at:
Telephone 843-853-2070
Fax 843-853-0044
E-mail sales@arcadiapublishing.com
For customer service and orders:
Toll-Free 1-888-313-2665

Visit us on the Internet at www.arcadiapublishing.com

*To Joslynn, Joshua, and Molly in hopes they will share a love of history
with me in the years to come.*

CONTENTS

ACKNOWLEDGMENTS

In 2002, the Phoenix Public Library and Phoenix Museum of History entered into a joint digitalization project under a Library Service and Technology Act grant from the Arizona State Library, Archives and Public Records Agency. The purpose of the project is to preserve, through digitization, the historical images of these two organizations. To date, over 3,500 images have been digitized and the project is on going. Two-thirds of the images used in this book came from these digitized images.

I wish to thank Maria Hernandez, Arizona Room librarian, Phoenix Public Library, for allowing me to use the James H. McClintock photographs and for being a great coworker and supporter throughout the writing of this book; Tracy Wagner, director of the Phoenix Museum of History; and Elizabeth Moser for allowing me to use the wonderful photographs the museum owns of early Phoenix. Thank you to Dr. Jack August, director of the Arizona Historical Foundation and his staff, Susan Irwin, Rebekah Tabah, and Linda Whitaker, for all their time and patience pulling boxes, photocopying, and digitizing images for me. I wish to thank Dr. James McBride, Arizona State University, for reading my introduction and giving me many valuable suggestions. Thank you to Jared Jackson, my editor, for all his help with the technical aspect of writing. Jared, you're a great editor.

And I want to thank my children Joseph, Kenneth, Elizabeth, Stephanie, and Michael and my grandchildren Joslynn, Joshua, and Molly for all their support and encouragement throughout this project; without them I never would have finished.

INTRODUCTION

It is alleged the name Phoenix was chosen because the town grew on the ruins of the ancient Hohokam Indians, just as the phoenix bird rose from its own ashes. In one aspect this is true, for if the Hohokam canals did not crisscross the Salt River Valley, Phoenix may not have become the metropolitan city it is today. In 1866, John Y. T. Smith, former Union army officer, began cutting wild hay along the Salt River and selling it to Camp McDowell. In 1867, John W. (Jack) Swilling, ex-Confederate soldier, prospector, farmer, and speculator, passed through the Salt River Valley and noticed the ancient canals of the Hohokam Indians. Swilling soon realized the farming potential of the area if the canals were cleaned out and put back into operation. Swilling immediately secured $10,000 in financial backing from supporters in Wickenburg and organized the Swilling Irrigating and Canal Company. After acquiring workers and supplies, Swilling moved to the Salt River Valley, cleaned out the ancient canals, and began delivering water to the rich soil.

By 1870, the Salt River Valley had over 130 settlers calling for a business center for the exchange of goods and services. On October 20, 1870, residents met under the leadership of John T. Alsap, a territorial legislator from Yavapai County and new arrival to the Salt River Valley from Prescott, who proposed a town site, but the citizens decided to appoint a committee of three to locate and recommend a town site. On October 26, the committee recommended the 320-acre site proposed by Alsap. The populous accepted the recommended town site and adopted the name Phoenix proposed by Darrell Duppa.

The citizens immediately elected John Alsap, James Murphy, and Joseph C. Perry as the first commissioners of the new Salt River Valley Town Association. William A. Hancock, a local storekeeper and secretary of the town association, was appointed to survey the new town site. Hancock laid out a town that contained 98 blocks, all separated by wide streets and alleys. Streets running east to west were named after United States presidents and streets running north to south after Native American tribes. The exception was Center Street, which ran north to south and intersected with Washington Street at the center of town.

The first lots sold for $20 to $140 with 60 lots purchased upon completion of the survey, though Alsap did not obtain deeds to the lots until April 1874. While Alsap worked to obtain legal deeds for the Phoenix town site, other promoters worked to bring about the creation of a new county out of the southern portion of Yavapai County. In February 1871, the territorial legislature passed a bill creating Maricopa County and selected Phoenix as county seat.

With Phoenix now the county seat, promoters began to look for the power, prosperity, and prestige this type of appointment usually brought. But Phoenix was far from a boomtown, and growth was slow during the first half of the 1870s.

In 1871, Phoenix population was at 400, and the area began to see the first permanent business structures in the new town site. The first public school, hotel, saloon, a second canal company, and the first lawyers admitted to practice in Maricopa County all came about in the first half of the 1870s. The second half of the decade saw the first telegraph office established, the incorporation

of a third canal company, the town's first newspaper, and the completion of a railroad at Maricopa, about 30 miles southeast of Phoenix. Phoenix was up and growing when the first banking institution opened, the first brick building was completed, and Arizona's first ice plant opened in 1879. By the end of the decade, Phoenix was providing many vital functions for the residents of the south central Arizona Territory.

During the 1880s, city fathers awarded contracts to private companies for water and gas works, electric lights, a streetcar line, and a telephone company. In 1883, Maricopa County supervisors ordered the construction of a courthouse fronting Washington Street between First and Second Avenues. City hall was completed in 1888 fronting Washington Street between First and Second Streets, two blocks east of the county courthouse.

In June 1885, the Arizona Canal was completed in the north valley. The first canal built on land not previously supplied by Hohokam canals, the Arizona Canal was 47 miles long, allowing for extensive expansion of cultivated lands. The valley saw many firsts take place in the agricultural industry during the 1880s, including the first ostrich farm, fig orchard, orange orchard, and other citrus and fruit orchards. Farmers needed railroad service closer than 30 miles away if they were to compete with the rest of the nation. Phoenix promoters began pushing for a railroad line linking Phoenix to the Southern Pacific at Maricopa. The dream was finally realized on July 4, 1887, when the first train of the Maricopa and Phoenix Railroad steamed into Phoenix. Phoenix was on its way, and many were calling it the "Garden City of Arizona."

Since 1864, the territorial capital had moved between Prescott and Tucson. In 1889, the territorial legislature voted to place the capital permanently in Phoenix. Phoenix received instant prestige, and business increased significantly with building permits at $488,000 in 1890. Promoters were now calling Phoenix the "Denver of the Southwest."

The 1890 census showed Phoenix's population had doubled in the past 10 years to 3,152. Phoenix's business district was also growing, extending to Monroe Street on the north and Madison Street on the south. The Phoenix Street Railway began operations along Washington Street from Seventh Avenue to Seventh Street, allowing residents to live farther east and west of downtown.

In 1892, Phoenix had six banks, two building and loan associations, seven churches, three schools, four volunteer fire companies, one business college, three cemeteries, and six newspapers. This year was also an important year for the Phoenix Indian School, which moved to a permanent location three miles north of the city on May 5. The school expanded over the next decade as more and more Native American students came to the school to be educated and assimilated into mainstream American life.

The first hospital in Phoenix, St. Joseph's Hospital, located at Polk and Fourth Streets was opened in 1895 by two Sisters of Mercy. It opened as a tuberculosis hospital consisting of six rooms that accommodated only 12 patients. But the hospital soon began taking all patients, and by the fall of 1896, it was enlarged to accommodate 24 private rooms.

Retail business in Phoenix changed in 1895 with the opening of the first of three first-class department stores. Sam Korrick's New York Store opened in 1895, followed by Goldwaters in 1896, and the Boston Store in 1897. All three stores operated along Washington Street within a few blocks of each other. Along with first-class retail stores were first-class hotels, catering to the Eastern tourists visiting Phoenix during the winter months. These hotels offered all the amenities found at hotels in Chicago or New York.

In 1895, the Santa Fe, Prescott, and Phoenix Railroad arrived in Phoenix, linking the town to the Atchison, Topeka, and Santa Fe Railroad in northern Arizona. With two major railroad connections, the valley was able to complete with markets around the nation, making Phoenix the agricultural center for south central Arizona.

The Salt River is the main water supply for Phoenix and the surrounding agricultural areas. But the river was not dependable, as witnessed during the first two years of the 1890s when floodwaters reached as far north as Jefferson Street in downtown Phoenix. The rest of the 1890s were basically drought years when little, if any, water flowed in the river. Phoenix businessmen,

farmers, and ranchers decided a water storage system was needed to remedy the situation and formed the Salt River Valley Storage Committee known today as Salt River Project.

In June 1902, Congress passed the Newlands Reclamation Act providing federal money for state reclamation projects. The valleys water problems were solved when the Salt River Project became the first of 26 reclamation projects authorized by the Department of the Interior. Construction on Roosevelt Dam began in 1904 and was completed in 1911. The Salt River Valley now had a reliable supply of water.

The new century commenced with Phoenix residents excited to see the many modern conveniences found in Eastern cities now part of their city. The automobile was one of these conveniences and first appeared in 1902 when Dr. James Swetnam began driving his Winton around Phoenix. Soon many of the elite of Phoenix were driving new automobiles, and by 1913, Phoenix had 10 automobile dealers. The automobile allowed residents to move to quiet neighborhoods on the outskirts of town.

The territorial capitol was dedicated on February 25, 1901, and residential neighborhoods developed around the capitol as well as north on Center Street and east as far as Sixteenth Street. As the city expanded, so did the street rail system, which had lines running to the Phoenix Indian School, the territorial capitol, territorial fairgrounds, and to the many new residential subdivisions developing around Phoenix.

Phoenix experienced many changes during the first decade of the 1900s. Pres. William McKinley paid the city a visit, the first president to do so, on May 8, 1900, giving the residents of Phoenix a reason to celebrate. There was a parade, speeches, a dinner, and celebrating all around. Phoenix's first library, the Carnegie Public Library located at Eleventh Avenue and Washington Street, was dedicated in 1908. The YMCA building was completed in 1910, and the Phoenix Women's Club was dedicated in 1911.

Phoenix's population was at 11,134 in 1910, a 100-percent increase in just 10 years. As the population grew, so did city services with streets paved in the downtown area, an improved sewer system, phone service to the West Coast, motorized vehicles for the fire department, a new courthouse, and a new post office and federal building. On February 14, 1912, President Taft signed the proclamation making Arizona a state. Phoenix was now a state capital, giving it more prestige and importance in its competition with cities such as Denver, Los Angeles, and San Francisco.

During World War I, Phoenix and the valley saw boom years as agriculture expanded. Cotton became an essential crop when foreign exports were cut off, and large quantities were needed in the production of tires and airplane fabric. There were over 800 miles of canals providing low-cost water from Roosevelt Dam and the Salt River, a far cry from the first canals built on the ancient Hohokam canal system.

In 1920, Phoenix had a population of 29,053, twenty-one miles of paved roads, 64 miles of sidewalks, 65 miles of gas lines, 7, 942 electric meters, 7,096 telephones, and 32 miles of street railway track. Phoenix first skyscraper, the Heard Building, was completed in 1920 by Dwight B. Heard on north Central Avenue between Washington and Adams Streets. The building stood eight stories and was to lead the way for the small township that grew to a major metropolitan city.

One

AN ADOBE TOWN
1870–1880

In a private letter dated December 10, 1870, John T. Alsap wrote of the new settlement of Phoenix, "We are having our town of Phoenix laid out, and I shall probably send you an advertisement before long for the sale of lots. Just now the farmers are pretty busy putting in their crops." On March 4, 1871, Alsap wrote, "Our town is improving, three new buildings being in course of erection, and others will be commenced as soon as the winter is a little past. The sale of town lots, thought not as great a success as the first [sale], was still as successful as was anticipated. Twenty-three lots were sold at good price. . . . I saw more ladies together last Sabbath than I have seen in one house before in 18 months." Alsap was Phoenix's first mayor and worked hard promoting the new settlement.

The original buildings of Phoenix were adobe, lumber being to costly, and were located along Washington Street, between First Street and First Avenue. Washington and Jefferson Streets ran east to west and were 100 feet wide. Center Street was also 100 feet wide and was the town's principal north-south street. All other downtown streets were 80 feet wide, and blocks were 300 feet long. All streets running east to west were named for United States presidents and streets running north to south for Native American tribes.

By 1878, Phoenix had six stores, three flour mills, a public school, four lawyers, four blacksmiths and livery stables, two hotels, one freighter, and three saloons. It was the county seat of Maricopa County, which gave the town prestige and added business from around south central Arizona.

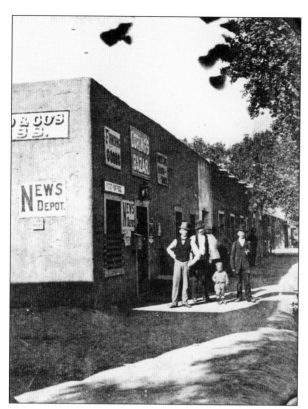

Lorings Bazar was on Washington Street between First and Center Streets in 1878 and housed a general dry goods store, the post office, and Wells Fargo. The Maricopa County Courthouse was in the building to the right of Lorings. The courthouse moved three times before a permanent building was constructed in 1883. (Courtesy Arizona Historical Foundation.)

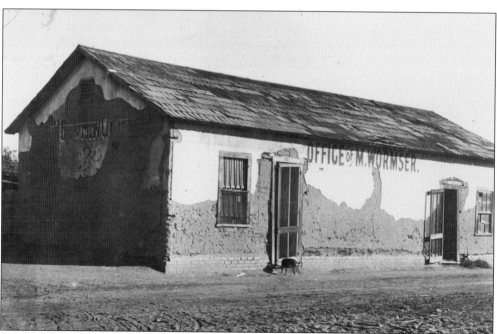

Michael Wormser owned a number of lots and buildings in Phoenix. The above photograph was taken in 1878 of one of Wormser's buildings located on Washington Street between Third and Fourth Streets. (Courtesy Arizona Historical Foundation.)

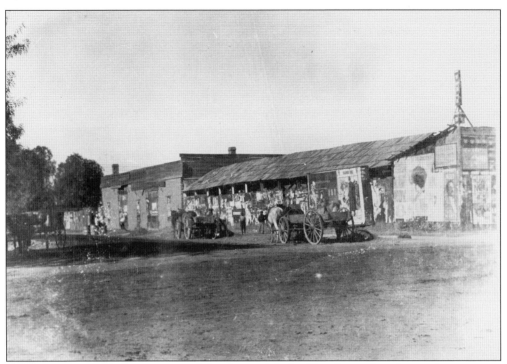

It is unknown what business occupied the above adobe building located on the northwest corner of Center Street and Madison Street. (Courtesy Arizona Historical Foundation.)

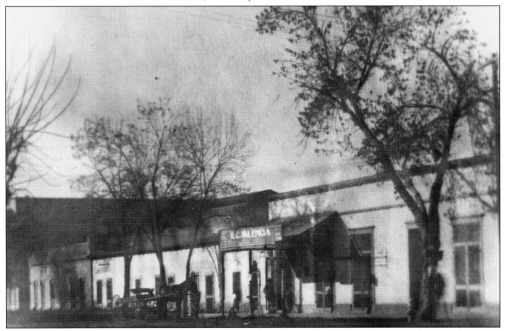

The above picture, taken in the 1870s, is of the northwest corner of Monroe and First Streets looking west on Monroe Street. The Roma Saloon was in the adobe building on the corner with Alberto Valencia's grocery store in the same building to the left of the saloon. The buildings to the left of Valencia's are unidentified. (Courtesy Arizona Historical Foundation.)

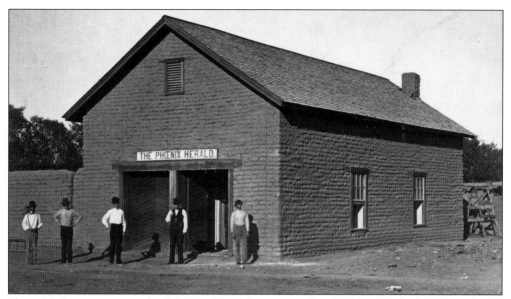

Phoenix's first newspaper, the *Salt River Herald*, was started in 1878 by Charles McClintock and was the forerunner of today's *Arizona Republic*. The above photograph was taken in September 1879; from left to right are E. I. Fuller, James H. McClintock (Charles's younger brother), William "Buckey" O'Neill, Charles McClintock, and Frank Robey. (Courtesy Phoenix Public Library.)

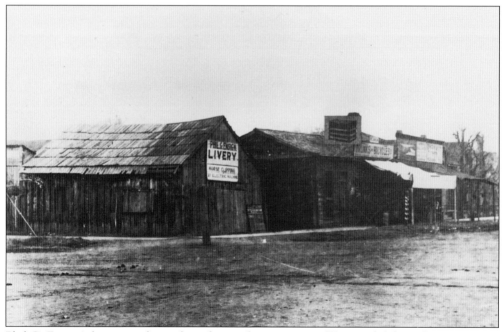

Phil G. Ensign's livery was located on the northeast corner of First and Adams Streets. Ensign advertised horse clipping by electric machine. (Courtesy Arizona Historical Foundation.)

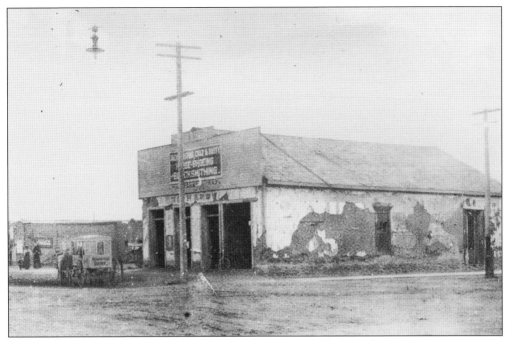

The establishment of Cruz and Duffy Horseshoeing and Blacksmithing was located on the southeast corner of Center Street and Jefferson Street. Later this corner was the location of the Phoenix Hotel. (Courtesy Arizona Historical Foundation.)

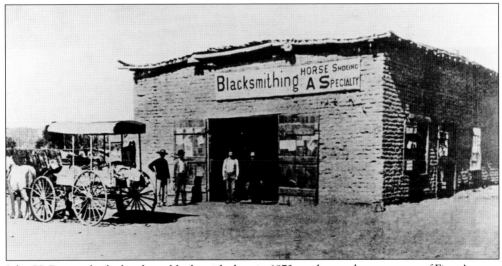

John H. Burgers built the above blacksmith shop in 1873 on the southwest corner of First Avenue and Adams Street. Burgers came to Phoenix in 1870 and was active in city politics. He served as councilman for the Second Ward in 1892. Burger sold the business in 1893 for $1,200. (Courtesy Phoenix Museum of History.)

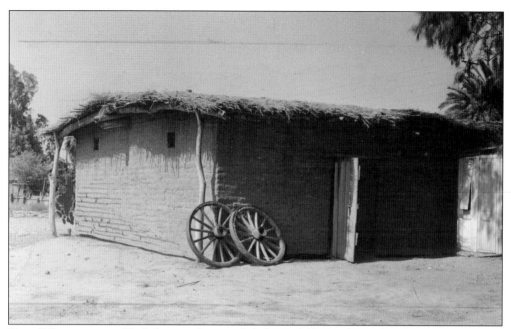

Darrell Duppa was an Englishman who traveled the world before being lured to Arizona by the mining boom of the 1860s. Duppa was part of the committee that chose the original Phoenix town site and is often credited with naming the town Phoenix. The above adobe was his Phoenix home. (Courtesy Phoenix Museum of History.)

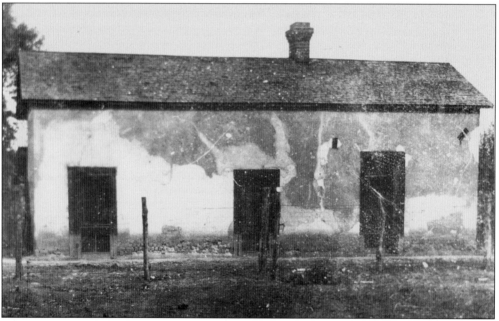

The above house was the last home of Charles Poston, located on Melinda's alley between Washington and Adams Streets and First and Second Streets. Poston came to Arizona in the 1850s looking for silver in Southern Arizona. He owned a large ranch until the Apache ran him off, though Poston later served as Arizona's superintendent of Indian Affairs. Poston is often referred to as the "Father of Arizona." (Courtesy Arizona Historical Foundation.)

Two

DOWNTOWN PHOENIX
1881–1920

By the 1880s, Phoenix was well on its way to being the show place of the Southwest that promoters hoped it would be. In 1884, Phoenix had 70 new buildings, 33 of them built in brick and frame rather than adobe. One- and two-story buildings were expanded to four-stories or more with elevators and other modern conveniences.

The county courthouse was constructed in 1884, city hall in 1888, and the territorial capitol building was dedicated in 1901. This meant growth and prosperity for Phoenix, and the men whose livelihood depended on her future. In 1887, the Phoenix Street Railway Company began service, which allowed residents to live farther from the downtown business district. The business district also expanded north and south of Washington Street and east and west of Third Street and Third Avenue.

By 1892, Phoenix had 6 banks, 7 churches, 1 opera house, 6 newspapers, 10 grocers, 11 hotels, 2 ice companies, and 18 lawyers. Phoenix was definitely growing, and it would keep growing into the next century. By 1897, Phoenix had three first-class department stores and four first-class hotels to accommodate the many Eastern visitors who were beginning to visit the valley during the winter months.

The 1900s saw the first automobiles in Phoenix, allowing housing developments to expand even farther from the downtown district. The automobile made it necessary for the city to invest in paved streets, first in the business district and then to residential neighborhoods.

By 1920, Phoenix had 21 miles of paved roads, 64 miles of sidewalks, 65 miles of gas lines, 7,942 electric meters, 7,096 telephones, and 32 miles of street railway track.

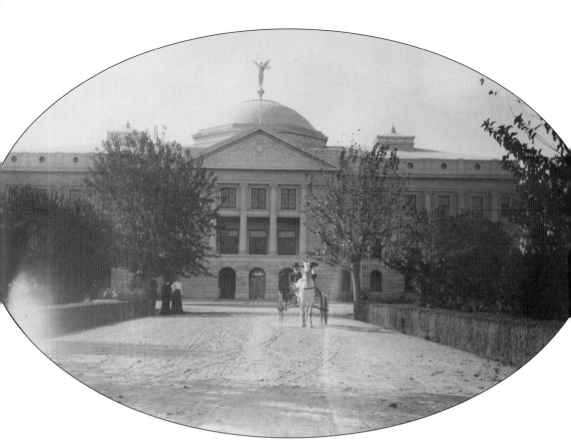

The territorial capital of Arizona moved from Prescott to Tucson and back again to Prescott before being permanently established in Phoenix on January 29, 1889. The legislature and territorial offices, including the governor, met on the upper floors of Phoenix City Hall until a building was constructed. The new capitol was designed by James R. Gordon on a site donated by Moses Sherman at Washington Street and Seventeenth Avenue. Ground was broken in 1898 with most of the construction materials indigenous to Arizona. A copper dome with a winged victory wind vane was the crowning glory of the building, which was dedicated on February 25, 1901. (Courtesy of Phoenix Museum of History.)

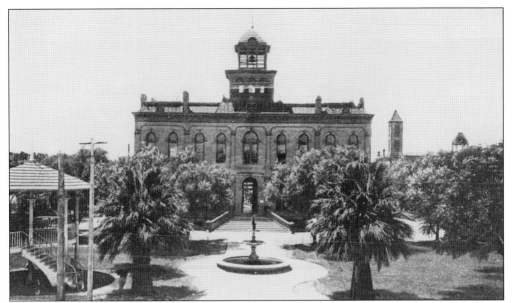

Phoenix City Hall, dedicated in 1888, was a handsome, three-story, brick building set on a plaza fronting Washington Street between First and Second Streets. The plaza was eventually covered in lush green grass, ornamental trees, and flowers and became the site of many public events. In 1905, a bell tower was added to summon the volunteer fire department. (Courtesy Arizona Historical Foundation.)

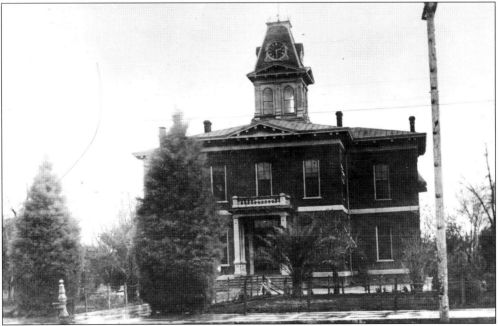

Phoenix became the county seat of Maricopa County in 1871. County offices were moved from building to building until 1884 when a courthouse was constructed on land reserved for that purpose on Washington Street between First and Second Avenues. A three-story building with an imposing clock tower, the courthouse was torn down in 1928 when a joint city-county complex was built on the site. (Courtesy Arizona Historical Foundation.)

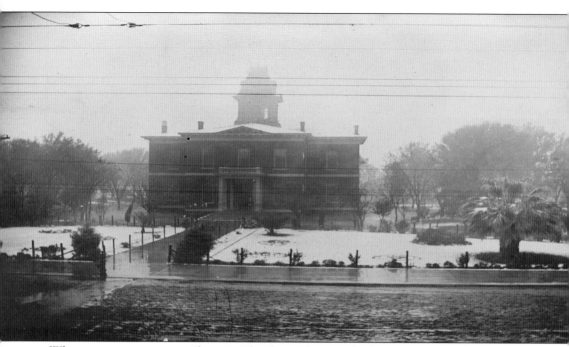

Who says it never snows in Phoenix? The above photograph, showing about an inch of snow on the ground and roof of the county courthouse, was probably from the snow storm of December 10, 1923, though the photograph is not dated. (Courtesy Arizona Historical Foundation.)

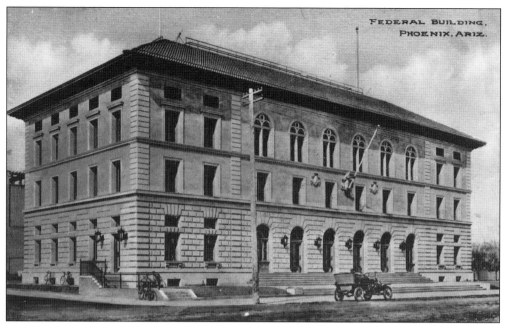

In 1913, Phoenix was very proud of its new Federal Building on First Avenue between Monroe and Van Buren Streets. The building had room for all federal offices, including the post office. The post office occupied most of the first floor with the federal attorney, courtrooms, and other federal offices on the top floors. The building was torn down in 1934 when a larger one became necessary. (Courtesy of Phoenix Public Library.)

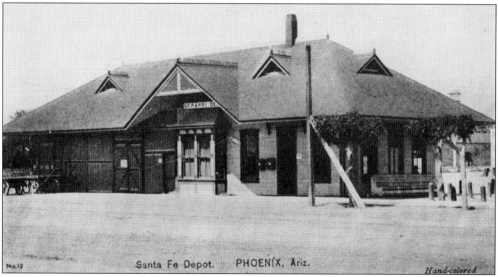

A railroad line connecting Phoenix to the Santa Fe Railroad was becoming a must-have by the late 1880s. With tax exemption from the territorial legislature, right-of-way, and land for a depot from the city of Phoenix, the Santa Fe, Prescott, and Phoenix Railway was incorporated in March 1891. The above depot, located at First Avenue and Jackson Street, was ready when the Santa Fe, Prescott, and Phoenix steamed into town on February 28, 1895. Phoenix was now connected by rail with Northern Arizona. (Courtesy Arizona Historical Foundation.)

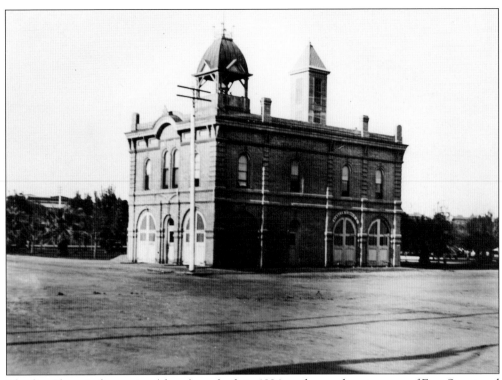

The first Phoenix fire station (above) was built in 1894 on the northeast corner of First Street and Jefferson Street. After two disastrous fires in 1885 and 1886, citizens authorized municipal bonds to buy equipment and construct a station. The station was manned by the Phoenix Volunteer Fire Department until June 15, 1915, when Phoenix established a full-time, paid fire department. The volunteers pulled the heavy fire equipment (below) until 1899 when horses were trained to do the job. In 1914, the fire department received three motorized trucks. Phoenix City Hall can be seen to the left of the fire station. (Both courtesy Phoenix Museum of History.)

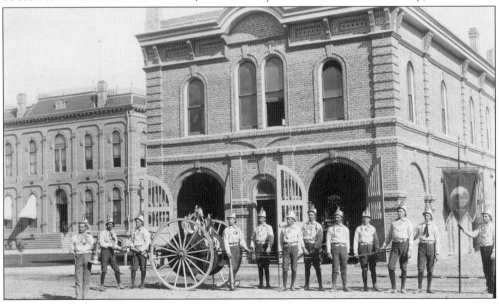

The above photograph shows Mayor James Monihon (in suit and hat) with members of the Phoenix Volunteer Fire Department in 1894. James Monihon came to Phoenix in 1872 and started the Phoenix Livery, Feed, and Stable on the northeast corner of Washington Street and First Avenue. In 1879, Monihon built a large three-story building on the property that became known as the Monihon Building. (Courtesy Phoenix Museum of History.)

The Phoenix Police Department in 1907 consisted of nine officers. The first professional police department was established in 1914 under city manager William Farish. At that time, the force was increased to 24 men and women. (Courtesy Arizona Historical Foundation.)

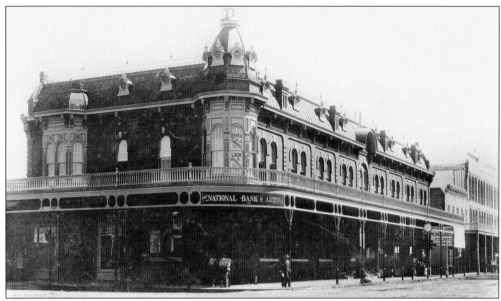

The very stunning Queen Anne–style Cotton Building stood on the southeast corner of Center and Washington Streets in the late 1880s. The building was home to the National Bank of Arizona from the time of the bank's incorporation in 1887. (Courtesy Arizona Historical Foundation.)

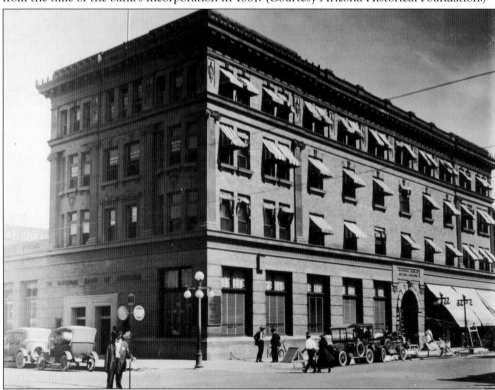

By 1910, the Cotton Building was replaced with this four-story brick building now belonging to the National Bank of Arizona. Note the police officer in the intersection of Washington and Center Streets directing traffic. (Courtesy Phoenix Public Library.)

In 1908, the Valley Bank built a modern building at 28–32 West Adams Street. Incorporated in 1883, the Valley Bank was operated by William Christy and his son Lloyd Christy from its inception until it closed in 1914. (Courtesy Phoenix Public Library.)

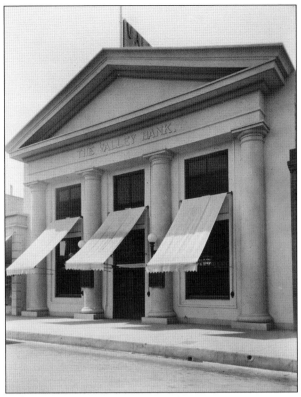

James A. Fleming built the Fleming Building in 1883 on the northwest corner of Washington Street and First Avenue. The building first consisted of two stories but experienced many changes through the years. In 1896, the building was increased to four stories, and the first elevators in Phoenix were installed. The building was home to the Phoenix National Bank from the time of its incorporation in 1892. (Courtesy Phoenix Museum of History.)

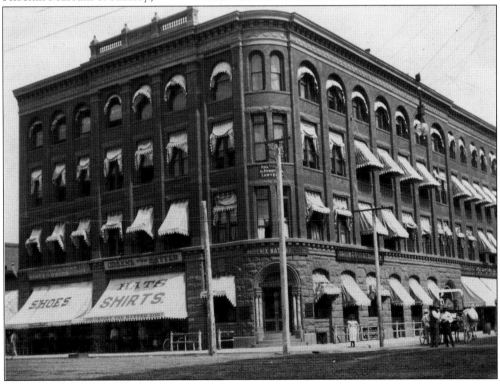

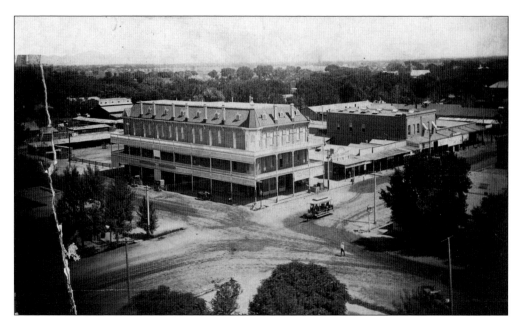

The growth of Phoenix becomes apparent on these two pages as the intersection of Washington Street and First Avenue is shown over a 30-year period. Three of the photographs were taken from the roof of the county courthouse with the photograph above taken in 1879. The three-story Monihon Building in the center of the photograph was built in 1879 by James D. Monihon. To the left of the Monihon Building, hidden by a group of trees, is a one-story adobe building owned by J. Otero. An interesting aspect of this photograph is the abundance of trees lining the streets. These trees would gradually disappear as the years progressed. The photograph below, taken in 1890, shows the Monihon Building in the center, with the two-story Fleming Building, built in 1883, to its left. The open area to the right is the county plaza. (Both courtesy Phoenix Museum of History.)

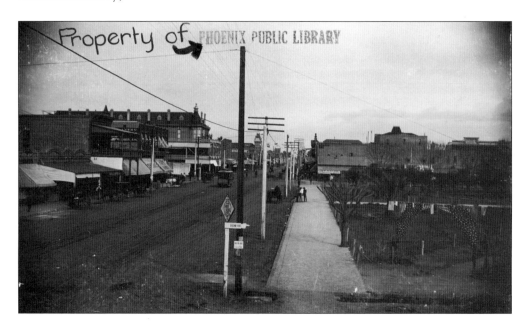

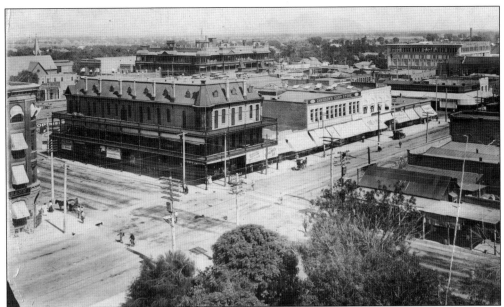

On this page, the intersection of Washington Street and First Avenue was photographed in about 1909 and 1915, with the Monihon Building in the center of both photographs. The Fleming Building on the northwest corner has been increased to four stories, and in the above photograph, the original Hotel Adams stands directly behind the Monihon Building. Many of the trees in the former photograph have disappeared, replaced by buildings. In the photograph below, the Monihon and Fleming Buildings are the same, but the Hotel Adams is now a large, fireproof, concrete structure. The original Hotel Adams burned in 1910. (Both courtesy Phoenix Museum of History.)

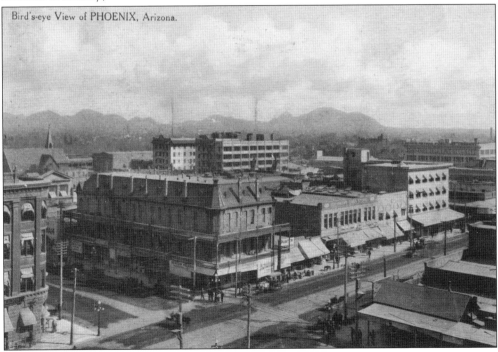

Bird's-eye View of PHOENIX, Arizona.

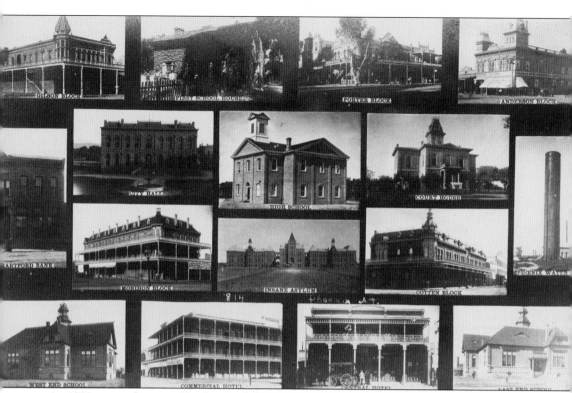

An 1889 postcard was used by the city fathers to promote Phoenix to Eastern investors and winter visitors as a thriving modern city. The card highlights the many modern buildings and amenities available in Phoenix at the time. (Courtesy Arizona Historical Foundation.)

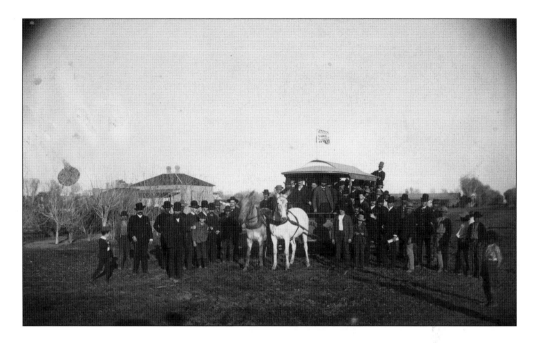

On November 5, 1887, the Phoenix Street Railway Company made its initial run along Washington Street from Seventh Avenue to Seventh Street. The first streetcars were drawn by mules with electric cars put into operation in 1893, and the tracks along Washington Street expanded to two lines. Rail services were expanded along Center Street in 1889 and continued to expand as new housing developments went up to the east, west, and north of downtown. (Both courtesy Phoenix Museum of History.)

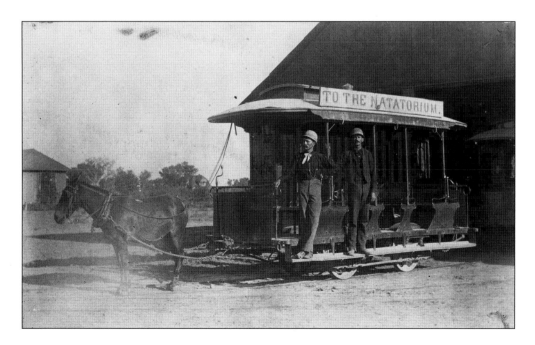

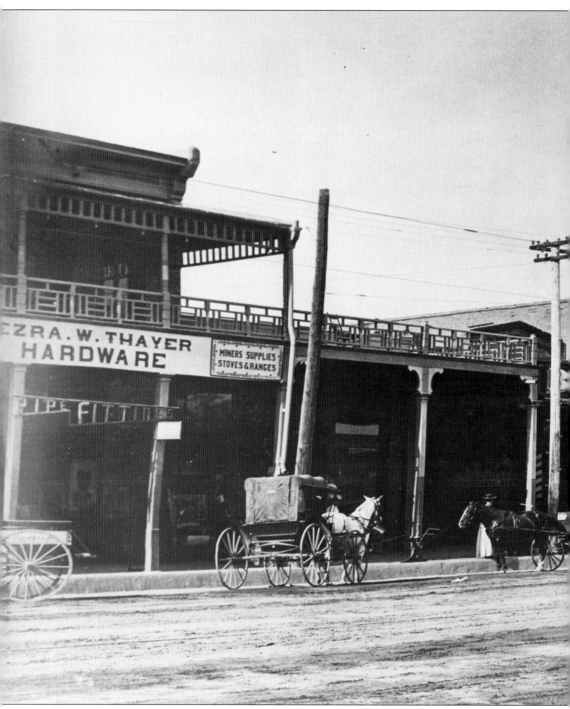

The buildings in this photograph, taken in the late 1890s, are the only buildings from that era still standing in downtown Phoenix. This is a view of the north side of Washington Street looking east between First and Second Streets. Ezra W. Thayer Hardware, opened in 1890, is on the extreme left, with Bob's Palace Saloon and the first Goldwaters store to the right of Thayer's. The Fry Building is on the northwest corner of Second and Washington Streets. The upper floor

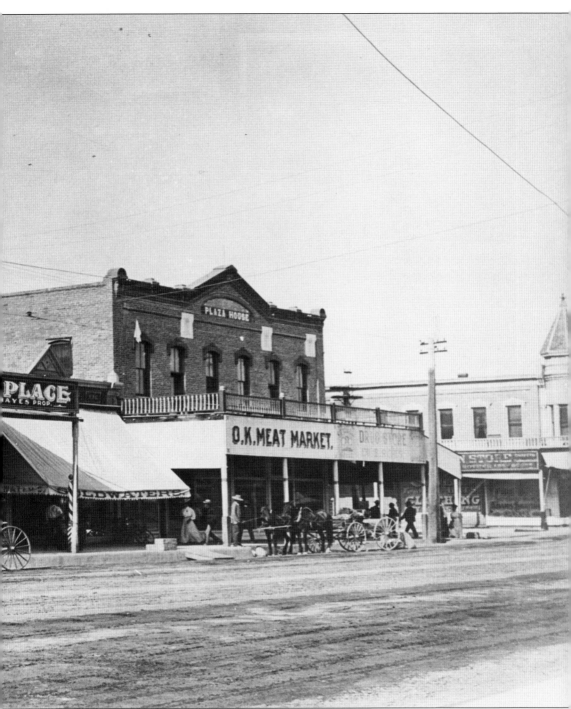

of the Fry Building housed the Plaza Boardinghouse, and on the ground floor, were the O. K. Meat Market and the Garden City Drug Store. To the far right is the Queen Anne–style Dennis Building. Today Majerle's Sports Grill is on the ground floor of the Fry Building. (Both courtesy Phoenix Museum of History.)

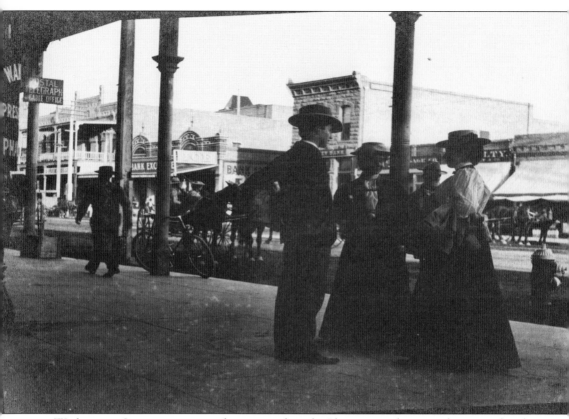

Washington Street was a natural meeting place for Phoenix residents, as shown in the above photograph. While these individuals are unidentified, they appear to be enjoying a leisurely chat. The two-story building behind the group was the original location of the Valley Bank at 42 East Washington Street. (Courtesy of Phoenix Museum of History.)

Washington and Second Streets was a busy intersection in 1900. The New York Store, one of Phoenix finest department stores, can be seen in the center of the photograph at 218–228 East Washington Street. The New York Store was owned by Sam Korrick, who came to Phoenix in 1895 and immediately opened the upscale store. To the left of the New York Store is the Dennis Building and the Capitol Hotel, to the right, is on the corner of Third and Washington Streets. The Stein Millinery sat on the southeast corner of Washington and Second Streets. (Courtesy Phoenix Museum of History.)

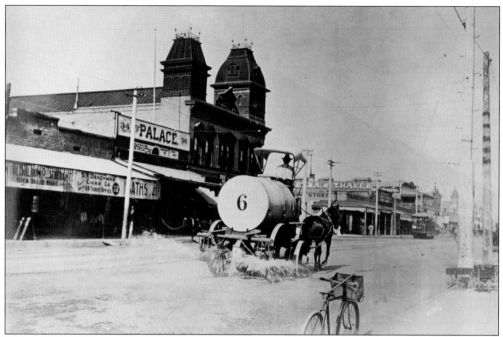

Washington Street was watered down to control the dust in 1900. The city did not begin paving its streets until January 1912 when 19 blocks of the business district were paved. This photograph shows the ornate Anderson Building on the northwest corner of Washington and First Streets. (Courtesy Phoenix Museum of History.)

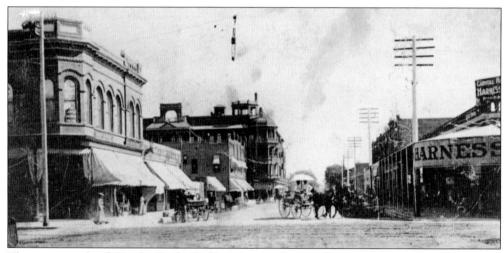

The two-story brick Kessler Boyle Building sits on the northeast corner of First Avenue and Adams Street in the early 1900s. Looking east down Adams Street is the original Hotel Adams on the northeast corner of Center and Adams Streets. The Hotel Adams, a massive brick and wood structure, was Phoenix's largest and grandest hotel until it was destroyed by fire on May 17, 1910. (Courtesy Arizona Historical Foundation.)

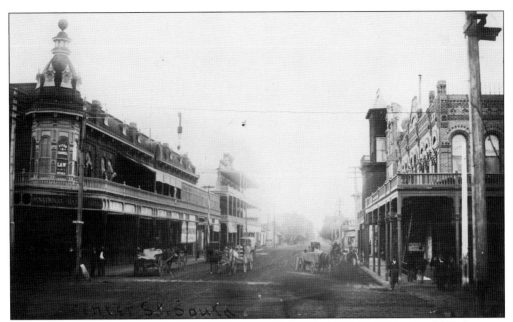

The above photograph is looking south down Center Street from its intersection with Washington Street in the early 1880s. The Cotton Building is on the left, and the Porter Building on the right; the Commercial Hotel is behind the Cotton Building. The three-story Commercial Hotel was a distinctive building with balconies surrounding two sides. (Courtesy Phoenix Public Library.)

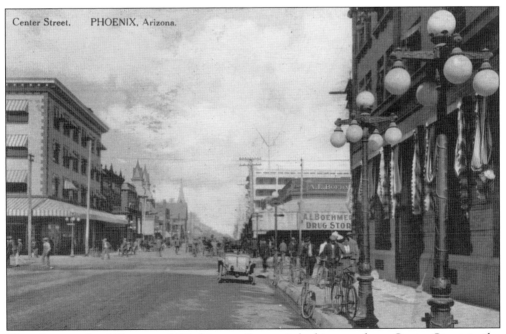

This photograph of Center and Washington Streets is looking north up Center Street in the early 1900s. On the northwest corner is the Goodrich Building, the tall building in the middle right is the Adams Hotel, and the National Bank of Arizona Building is to the extreme right. (Courtesy Phoenix Public Library.)

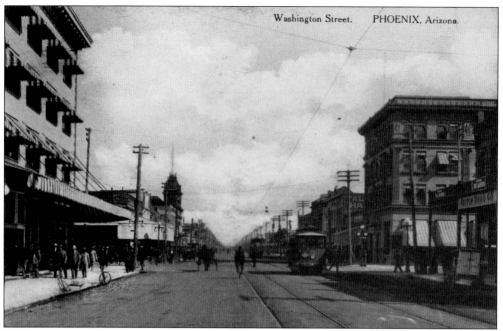

On Washington Street looking east in 1900, an electric streetcar is stopped at the intersection of Center and Washington Streets. The Goodrich Building is on the far left, and the Anderson Building with its tall turrets is in the center; on the left is the four-story National Bank of Arizona Building. (Courtesy Phoenix Public Library.)

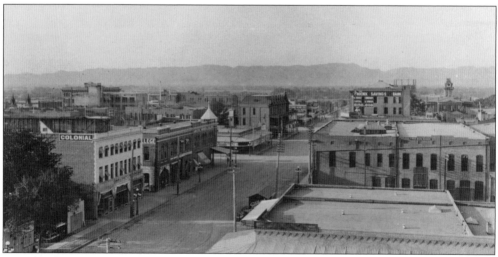

A view of First Avenue taken from the Federal Building looking south shows the intersection of First Avenue and Adams Street. The Blake Building is on the northeast corner of First and Adams with the Security Building on the southeast corner of the intersection. The Monihon Building is behind the Security Building on the northeast corner. To the far left, the clock tower of the county courthouse can be seen. (Courtesy Phoenix Public Library.)

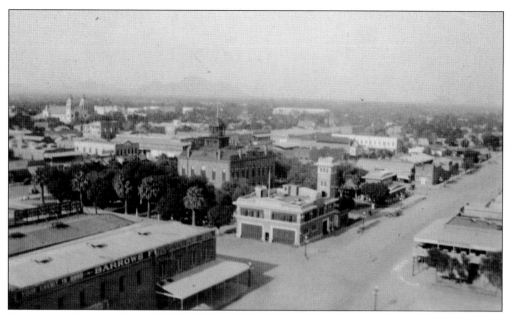

The above photograph was taken from a balloon looking east along Jefferson Street. In the center of the photograph is the central fire station on the corner of Jefferson and First Streets with city hall on the left. Across from the fire station is the Phoenix Hotel on the southeast corner of Jefferson and First Streets. In the upper left is St. Mary's Catholic Church with its bell towers standing out against the horizon. (Courtesy Phoenix Museum of History.)

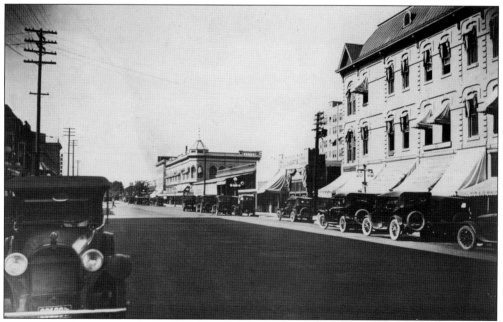

First Avenue, looking north, is lined with automobiles instead of horses and buggies in the 1920s. On the far left is the remodeled Monihon Building, and in the center is the Balke Building with its distinctive Victorian tower on the northeast corner of First Avenue and Adams Street. (Courtesy Phoenix Public Library.)

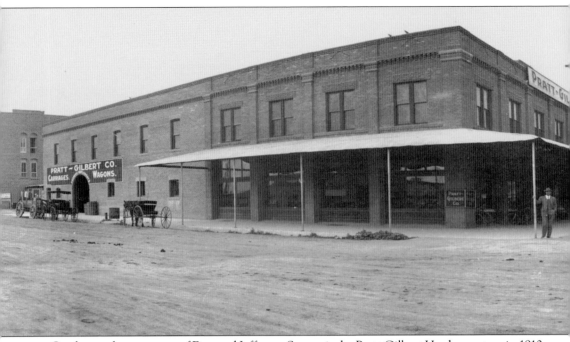

On the northwest corner of First and Jefferson Streets is the Pratt-Gilbert Hardware store in 1910. A corner of the Commercial Hotel is to the left of Pratt-Gilbert, and the central fire station is on the northeast corner of the intersection. Looking north up First Street are the towers of the

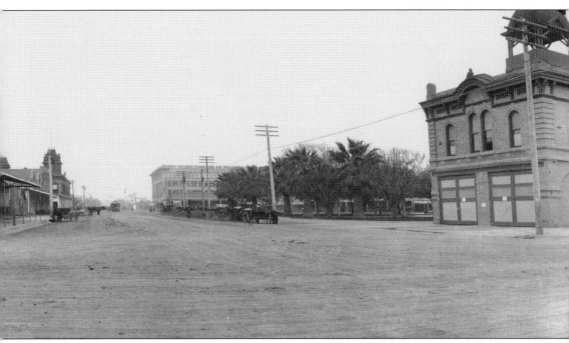

Anderson Building, and the Dorris-Heyman Furniture store is to the right with City Plaza in between Dorris-Heyman and the fire station. This section of First Street between Washington and Jefferson Streets was the first block paved in 1912. (Both courtesy Arizona Historical Foundation.)

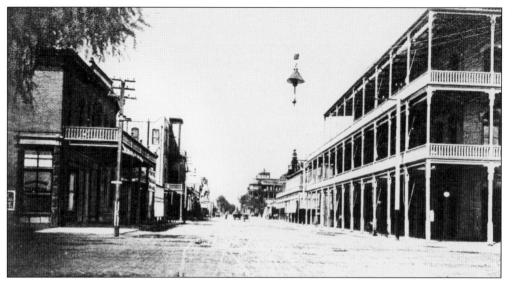

On the northeast corner of Jefferson and Center Street stood the impressive Commercial Hotel, opened in January 1887 by George H. N. Luhrs. This photograph was taken on April 16, 1907, showing the hotel after it was enlarged four times until it covered an entire quarter block. Looking north along Center Street, the last building on the right is the Adams Hotel. Both the Commercial and Adams were considered first-class hotels in the early 1900s. The object hanging in the middle of the First and Jefferson Streets intersection is a streetlight. (Courtesy Arizona Historical Foundation.)

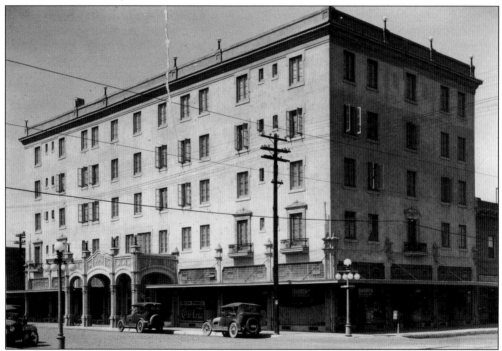

The Arizona Hotel, owned and operated by H. L. Bird, was located on the southwest corner of Washington and Third Avenue. This photograph shows a number of automobiles parked in front of the hotel. (Courtesy Phoenix Museum of History.)

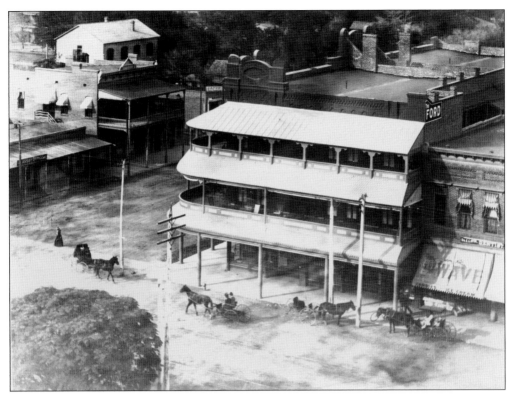

The Ford Hotel, a large, three-story, brick building on the northeast corner of Washington Street and Second Avenue, was built by Dr. James M. Ford. Dr. Ford came to Phoenix from Kansas City in 1895 and began investing in real estate. The Ford Hotel was considered one of the finest hotels in the Southwest when it opened in 1896. The porches of the hotel, below, were used as sleeping areas for guests during the hot summer months. (Both courtesy Arizona Historical Foundation.)

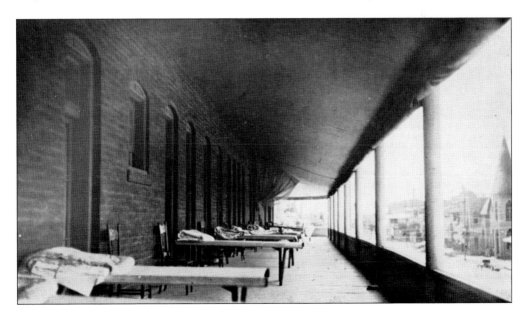

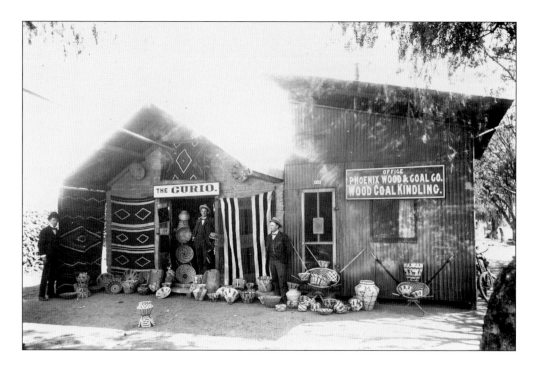

The Curio was owned and operated by J. H. Benham at Second Avenue and Jefferson Street. The above photograph shows the front of the building with Native American curios displayed for all to see. From left to right are Paul Bryard, J. H. Benham, and Will Barne. The photograph below shows J. H. Benham and his wife inside the store. (Both courtesy Arizona Historical Foundation.)

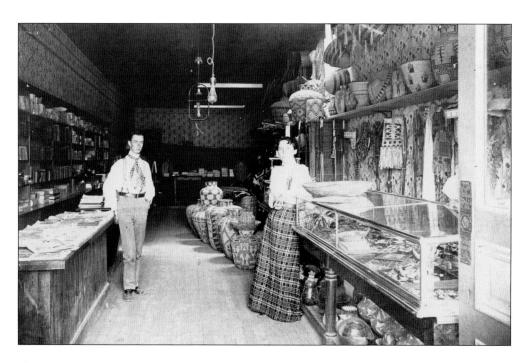

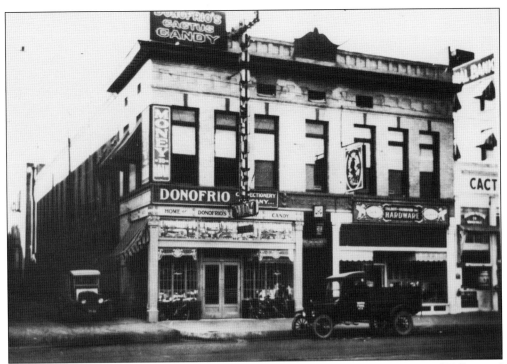

The Ellingson Building at 21 East Washington housed Donofrio's Confectionary and Talbot and Hubbard Hardware store. Designed in the Renaissance Revival style in 1899 by James Creighton, one of Phoenix's first architects, the building had a central entrance leading to the second story, which housed many businesses, including doctors and dentists offices, fraternal lodge meetings, real estate offices, and a game arcade. Note the stained-glass transom under the Donofrio name. (Phoenix Museum of History.)

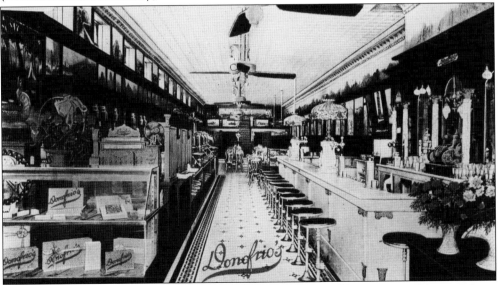

Donofrio's was an inviting place for Phoenix residents to stop and have an ice cream or soda on a hot summer day in the early 1900s. Customers could buy cactus candy and flowers as well as ice cream. (Courtesy Arizona Historical Foundation.)

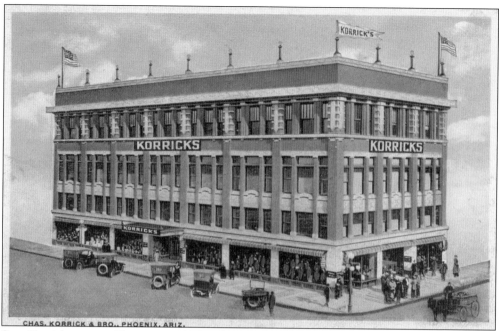

CHAS. KORRICK & BRO., PHOENIX, ARIZ.

Sam Korrick came to Phoenix in 1895 and on October 6, 1895, opened the New York Store on Washington between Second and Third Streets. The store was only 14 by 25 feet when Sam opened with $1,000 in merchandise. By 1915, the New York Store had grown until Charles Korrick found it necessary to build a new, four-story, brick building to house their merchandise. The name was changed to Korrick's, and the new store opened in November 1914 on the northeast corner of Washington and First Streets. The photograph below shows the interior of the store at about the time of the 1914 opening. (Both courtesy Phoenix Public Library.)

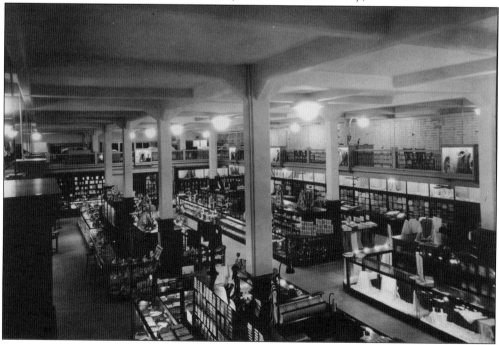

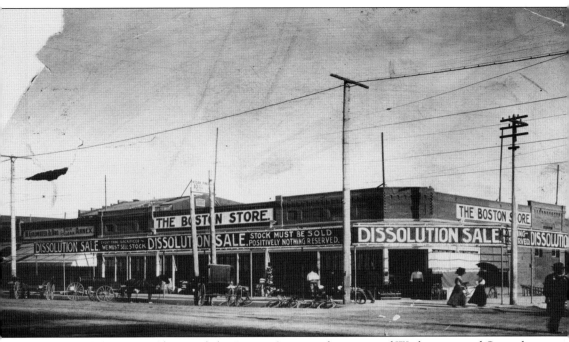

Nathan and Ike Diamond opened the Boston Store on the corner of Washington and Second Streets in January 1897. The Diamond brothers came to Phoenix in 1896 after hearing of Phoenix's potential from their former clerk Sam Korrick. There were now three first-class department stores in Phoenix that carried everything from women's clothing and cosmetics to housewares and furniture. (Courtesy Arizona Historical Foundation.)

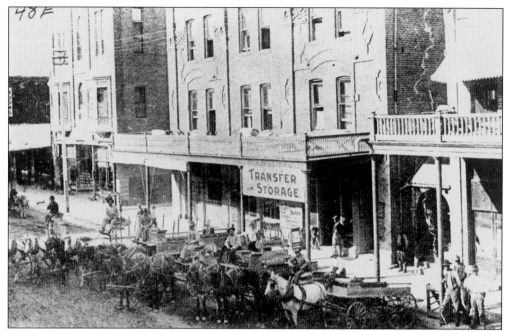

The Lightning Transfer and Storage Company on Center Street between Washington and Jefferson Streets lined up their wagons and drivers for this photograph taken in the 1880s. Freighting by wagon was big business before the railroad came into Phoenix. By March 1895, Phoenix had two railroads, which numbered the days for horse- and mule-drawn freight companies. (Courtesy Arizona Historical Foundation.)

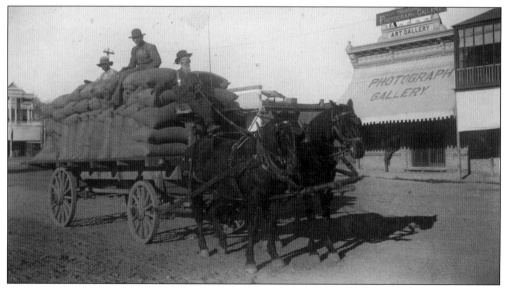

D. S. Bewley ran a freighting business that advertised as the "Oldest and Most Reliable" drayman in Phoenix. Bewley was out of business by 1895, most likely because of the railroads coming to Phoenix. (Courtesy Phoenix Museum of History.)

Phoenix had many impressive buildings lining the main business section along Washington, Adams, and Jefferson Streets, but it also had many smaller businesses that helped make the city prosper. Vance Brothers Baking Company, at 110 South Third Avenue between Jefferson and Madison Streets, was one such business. Owned and operated by Frank T and J. Mont Vance, the bakery provided an important service to the city. (Courtesy Phoenix Public Library.)

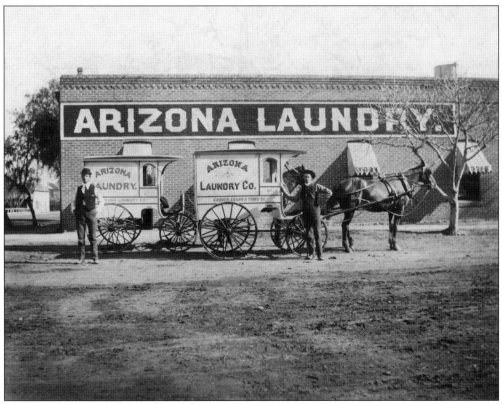

Another business establishment that was not part of the Phoenix main business center was the Arizona Laundry operated by the Kolberg family for more than 50 years. This picture shows the drivers and wagons used to pick up and deliver laundry to Phoenix residents in the early 1900s. (Courtesy Phoenix Museum of History.)

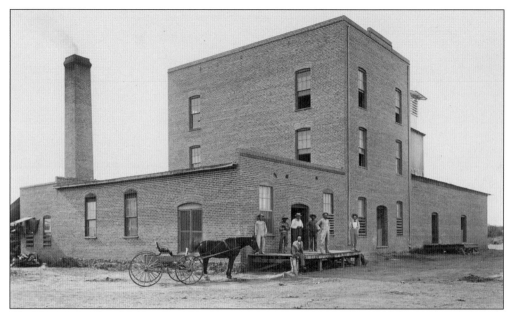

The Phoenix Milling and Trading Company was incorporated in 1890 by John Y. T. Smith, John Gray, and G. V. H. Shaver. The mill was located at Ninth and Jackson Streets across from the Maricopa and Phoenix Railroad depot. John Y. T. Smith was the first settler in the Salt River Valley; this was Smith's second flour mill. (Courtesy Phoenix Museum of History.)

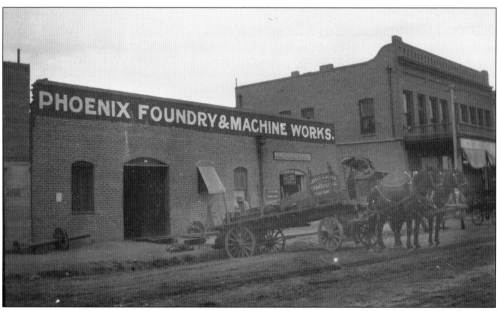

Phoenix Foundry and Machine Works was established about 1908 at 501 South Seventh Avenue by S. H. Rogers. (Courtesy Phoenix Museum of History.)

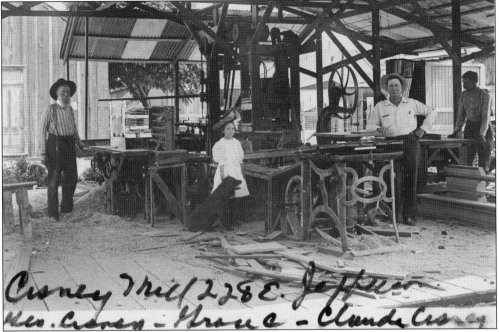

The Cisney family operated Cisney and Cisney Building Contractors, located behind their home at 228 East Jefferson Street. Claude Cisney was a civic-minded man who served as councilman for the Fourth Ward in 1908–1909. Standing by their equipment from left to right are George Cisney, Grace Cisney (note Grace's stylish hat), Claude Cisney, and unidentified. (Courtesy Phoenix Museum of History.)

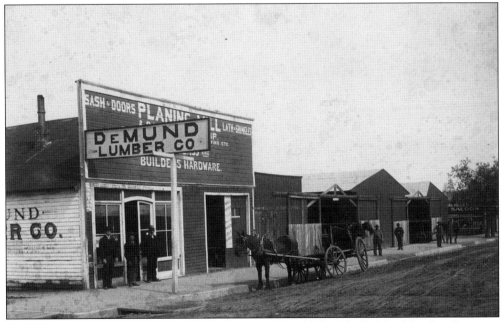

H. P. DeMund moved his family to Phoenix in 1895 and established the DeMund Lumber Company at 147 South Fourth Avenue. DeMund sold his lumber business in 1910 when he became interested in real estate and investment. (Courtesy Phoenix Museum of History.)

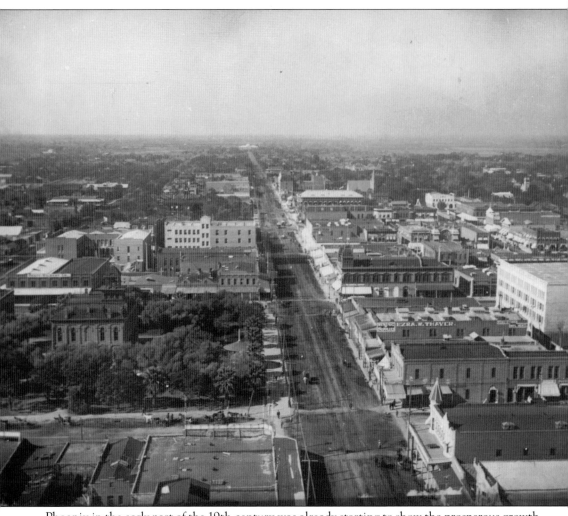

Phoenix in the early part of the 19th century was already starting to show the prosperous growth that was yet to come. This photograph, taken from a balloon in about 1908, is looking west along Washington Street from about Third Street. The city hall and plaza are on the right surrounded by trees. Looking west down Washington Street, the territorial capitol is barely recognizable on the horizon. (Courtesy Phoenix Museum of History.)

Three

PHOENIX MOVERS AND SHAKERS

Phoenix grew and prospered through the hard work and determination of men willing to take chances to attain their dreams. John Y. T. Smith, Jack Swilling, John Alsap, William Hancock, and Columbus Gray were some of the first to recognize the potential, mainly in agriculture, of the Salt River Valley and make it their home. Soon professional men like John C. Adams, James Monihon, Emil Ganz, W. J. Murphy, William Christy, Dwight B. Heard, and James H. McClintock, to name only a few, came to Phoenix to make their fortunes. They were doctors, lawyers, hotel keepers, merchants, newspapermen, bankers, and land speculators who set up businesses in downtown Phoenix.

These were civic-minded men who worked hard to improve the city by building schools, churches, a fire department, sidewalks, paved streets, and water and sewer systems. John Alsap, Emil Ganz, and James Monihon served terms as Phoenix's mayor, while others sat on the city council and board of trade. In 1871, John Alsap, William Hancock, and others worked to have Phoenix proclaimed the county seat of the new Maricopa County; in 1889, these same men worked to make Phoenix the permanent capital of the Arizona Territory. The acquisition of these important government institutions meant Phoenix was sure to see growth and prosperity in the years to come.

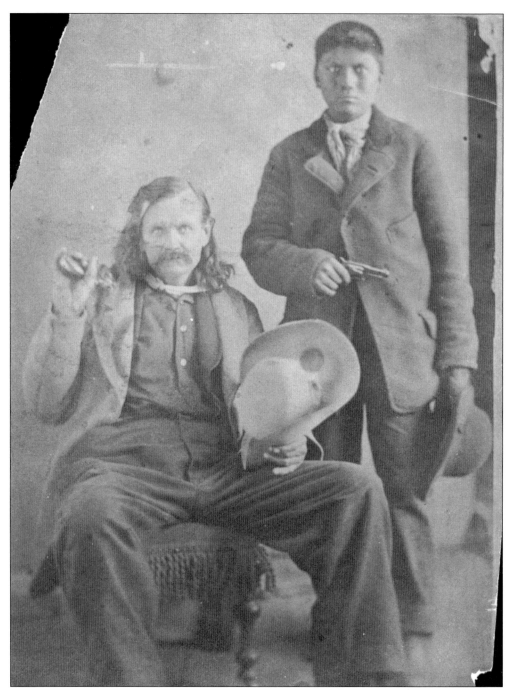

John W. (Jack) Swilling came to Arizona following the Civil War seeking gold. A former Confederate soldier and deserter, Union army scout, farmer, speculator, and miner, Swilling was the first to see the value of the ancient Hohokam canals running across the Salt River Valley. Swilling organized the Swilling Irrigating and Canal Company in 1867 to bring water to the Phoenix desert. Swilling is shown in about 1870 with an unidentified young man. (Courtesy Phoenix Public Library.)

John Alsap arrived in Phoenix from Prescott in 1869 with degrees in both law and medicine. Alsap served two terms in the territorial legislature, was appointed Maricopa County's first probate judge, and served as Phoenix's first mayor. On April 10, 1874, Pres. Ulysses S. Grant issued a patent for the town site of Phoenix to Alsap. As an attorney, Alsap represented many canal companies in regards to water rights around Phoenix. Alsap was always one of Phoenix's biggest promoters. (Courtesy Phoenix Museum of History.)

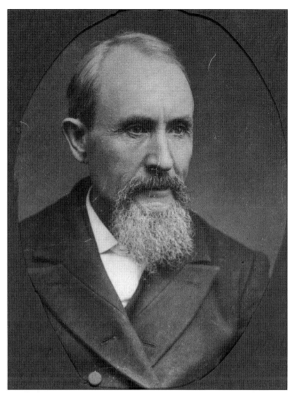

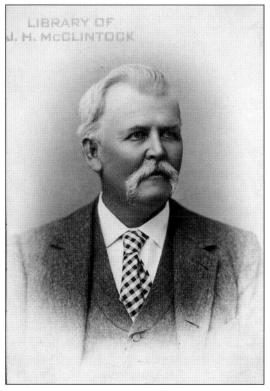

Columbus H. Gray and his wife, Mary Adeline, came to the Salt River Valley in 1868 and homesteaded 320 acres, farming barley, alfalfa, and onions and raising horses and cattle on what is today South Seventh Street. Columbus Gray helped dig the Dutch canal, a branch of the Swilling canal. Gray was a member of the first Board of Supervisors for Maricopa County and was elected to one term as senator in the territorial legislature. (Courtesy Phoenix Public Library.)

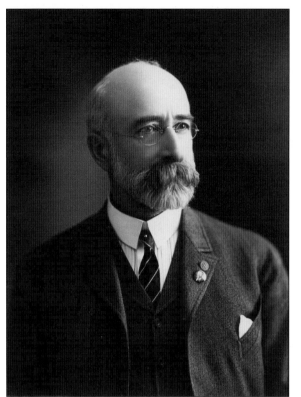

Benjamin Austin Fowler was a lawyer who arrived in Phoenix from New York City in 1899 with the hope of farming and enjoying a more leisurely life. But in order to farm, Fowler needed a reliable supply of water and thus began a 17-year fight to get a water reservoir on the Salt River. Fowler, as president of the Salt River Valley Water Users Association, was largely responsible for the completion of Roosevelt Dam in 1911. (Courtesy Phoenix Public Library.)

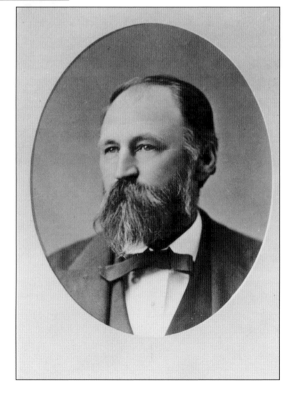

William A. Hancock came to the Salt River Valley in 1870 after mustering out of the U.S. Army. Hancock had knowledge of surveying and was chosen to survey the original Phoenix town site. He built the first adobe building in Phoenix, was postmaster for eight years, district attorney for four years, and Maricopa County's first sheriff. (Courtesy Arizona State University Libraries, Department of Archives and Special Collections.)

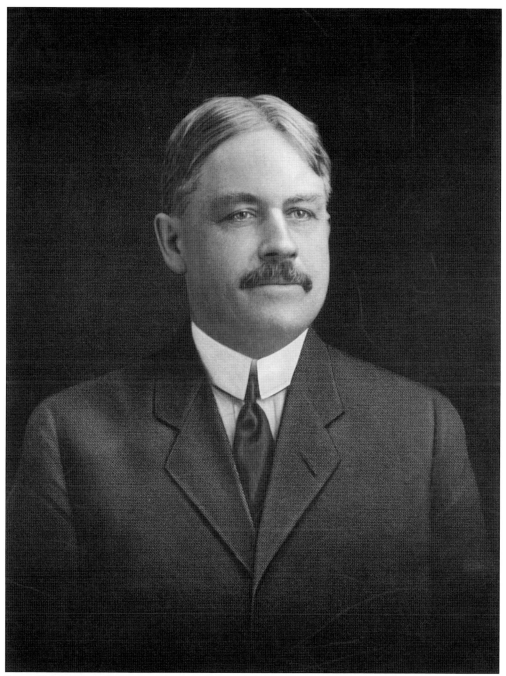

James H. McClintock came to Phoenix from California in June 1879 to work for his brother Charles at the *Salt River Herald*. This began a long and respected newspaper career for McClintock. In 1897, he helped organized Troop B of the U.S. Volunteer Cavalry, later called the Rough Riders during the Spanish-American War. He was appointed Phoenix postmaster in 1902 and state historian in 1919. In 1916, McClintock wrote *Arizona: Prehistoric-Aboriginal-Pioneer and Modern*, which is still considered one of the best histories on Arizona to that time period. (Courtesy Arizona State Library, Archives and Public Records, Archives Division, Phoenix, No. 97–7055.)

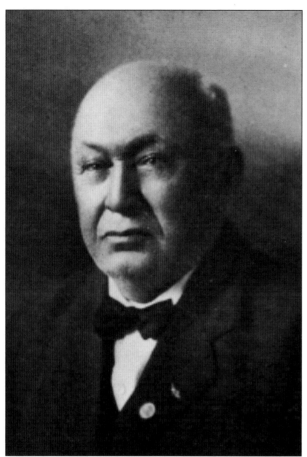

Emil Ganz arrived in Phoenix from Prescott in 1879 and opened the Bank Exchange Hotel at 23 West Washington Street. In 1885, Ganz started a wholesale liquor business at Washington Street and First Avenue, which he operated until 1895. Upon selling his liquor business, Ganz was elected president of the National Bank of Arizona, a position he held for the next 25 years. Emil Ganz served two years on the city council before being elected mayor of Phoenix in 1885 and again in 1899. In the image below, Ganz (far left) is standing in front of his liquor store with D. S. Bewley to his right, while the other men are unidentified. (Left, courtesy Arizona State Library, Archives and Public Records, Archives Division, Phoenix, No. 97-6377; below, courtesy Phoenix Museum of History.)

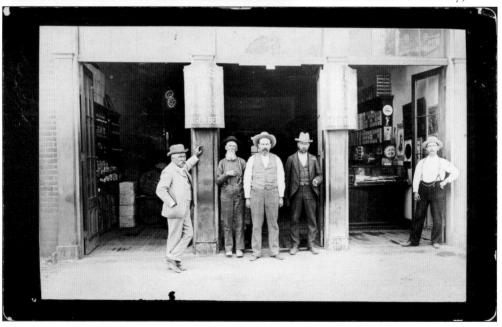

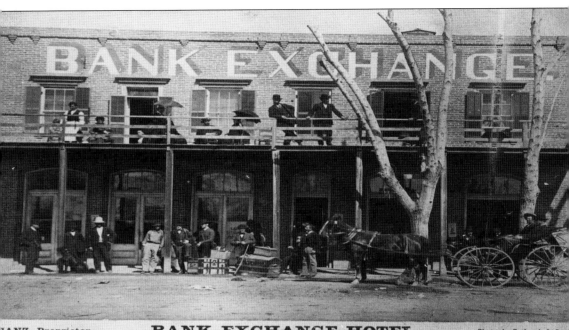

ANZ, Proprietor. **BANK EXCHANGE HOTEL,** Photo. by Rothrock & Cat

Emil Ganz built the Bank Exchange Hotel in 1879 at 23 West Washington Street. Ganz operated the hotel until it burned on April 26, 1885, in one of the most destructive fires in the city's history when 13 businesses burned to the ground. Phoenix had no fire department or water works at the time, only a bucket brigade from the town ditch. Ganz, mayor at the time of the fire, worked hard trying to convince the city council to put in a better water supply and fire department. But it took another major fire on August 6, 1886, before a bond issue was passed to build a water works plant and buy equipment for a volunteer fire department. (Courtesy of Phoenix Public Library.)

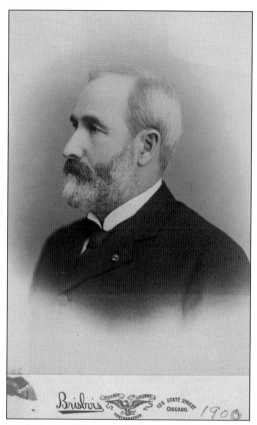

William J. Murphy, W. J. to his friends, came to Arizona in 1880 as a railroad grading contractor for the Atlantic and Pacific Railroad crossing northern Arizona. In 1883, Murphy took a contract to build the Arizona Canal in the northern part of the Salt River Valley. Murphy became president of the Arizona Canal Company, the Arizona Improvement Company, and the Phoenix Trust Company. Murphy planted the first citrus orchard in 1890. He was instrumental in advancing the towns of Glendale and Peoria during his promotion of the Arizona Canal. Murphy's offices were in the O'Neill building, below, at 102 West Adams Street. (Both courtesy Phoenix Museum of History.)

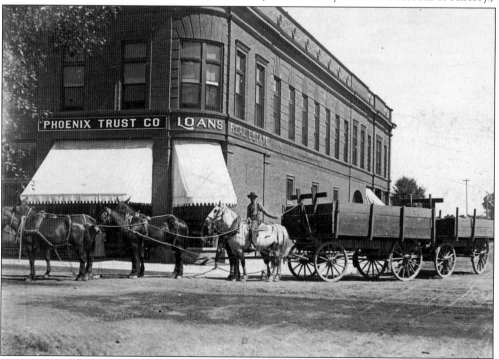

Samuel D. Lount arrived in Prescott, Arizona, in 1877–1878 and immediately began plans to build an ice plant in Phoenix. The plant began production on June 17, 1879, with ice selling for 6¢ per pound. The plant was located on Washington and Fourth Streets, and Phoenix residents were happy to line up for the luxury of ice in a desert city. (Right, courtesy Phoenix Museum of History; below, courtesy Arizona Historical Foundation.)

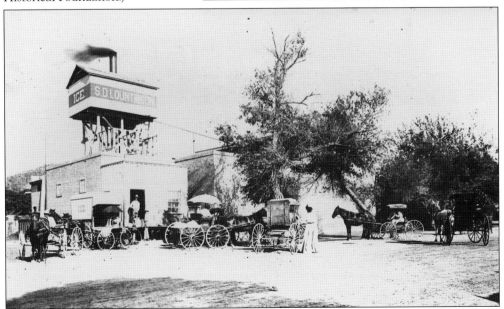

John C. Adams came to Phoenix in 1896 from Chicago and purchased the block on the northeast corner at Adams and Center Streets. Adams, shown at left on March 3, 1902, erected a beautiful, four-story, brick and timber hotel consisting of 150 rooms, large verandas on each floor, a large dining room, and a roof garden. The hotel was popular with mining executives, cattlemen, and tourists as well as the territorial legislature. On May 17, 1910, the *Arizona Republican* wrote, "Legislators might come and go, but the laws of Arizona were universally enacted under the dome of the Adams Hotel." Adams was very involved with the Republican Party and was elected mayor of Phoenix in 1897 and 1905. The hotel is shown in all its glory in the photograph below. (Left, courtesy Phoenix Museum of History; below, courtesy Arizona Historical Foundation.)

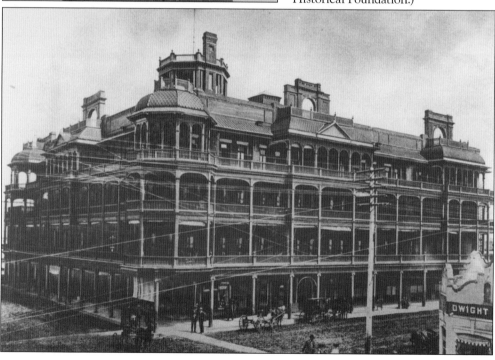

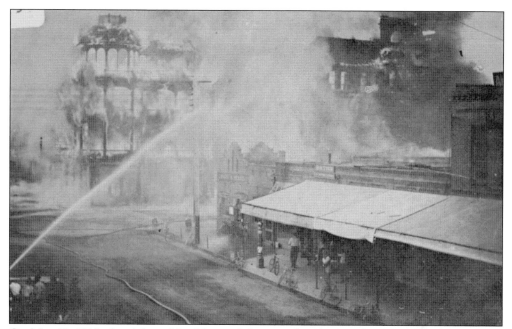

On May 17, 1910, the Adams Hotel burned, leaving the Phoenix landmark a total loss. The Phoenix volunteer fire department could do nothing but keep the flames from spreading to other buildings. No one was injured, but territorial governor Richard Sloan and his wife, Mary, had to flee the hotel with only the clothes on their backs. The fire did not discourage Adams, who built a larger and finer hotel within the year. The new hotel, shown below, was billed as absolutely fireproof, with 250 rooms, 150 with private baths, and two large dining rooms. The Adams Hotel was again home to the territorial legislators when in session. (Above, courtesy Arizona Historical Foundation; below, courtesy Phoenix Public Library.)

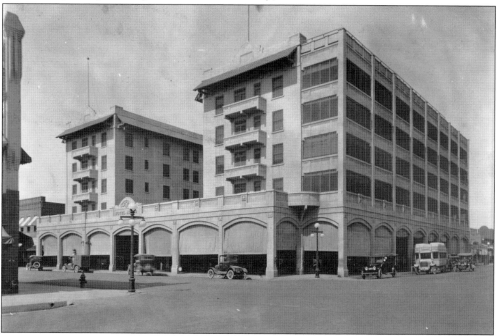

The Goldwater family operated stores and a freighting business in Arizona since 1862. Baron Goldwater, pictured, was a handsome man who always dressed impeccably, wore cologne, and had a natural flair with people. On March 23, 1896, M. Goldwater and Brothers opened an upscale department store on North First Avenue with Baron as store manager. Goldwaters became the leader in fine women's clothing and cosmetics because of Baron Goldwater's philosophy of "pleasing the ladies" of Phoenix. The store became so popular that by 1902, it had outgrown the First Avenue location and moved to larger quarters at 136 East Washington Street. But even this larger space became too small, and merchandise had to be split between two stores. The photograph below shows the Dorris-Heyman Building under construction in 1907; Goldwaters moved into the first floor and basement in December 1909, combining all its merchandise in one location. The second and third floors housed the Dorris-Heyman Furniture Company. (Both courtesy Arizona Historical Foundation.)

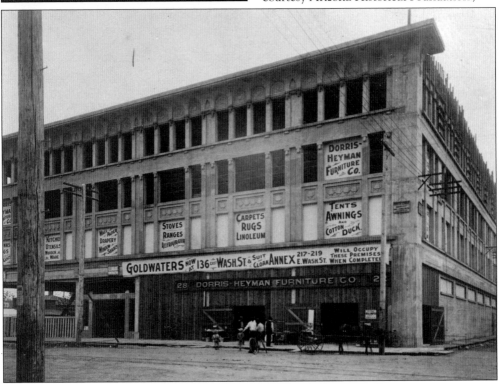

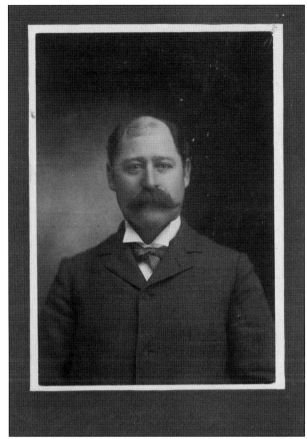

Aaron Goldberg and his father, Hyman Goldberg, opened the first Goldberg Dry Goods store in 1875 in a one-story adobe building on Washington Street between First and Second Streets. By the 1890s, Aaron and his brother, David, had established Goldberg Brothers Shoe and Clothing Store, specializing in men's and boy's clothing and furniture. Their store, pictured below, was located on the northeast corner of Washington and First Streets and boosted of being the first store in Phoenix to have plate glass windows. (Right, courtesy Phoenix Public Library; below, courtesy Phoenix Museum of History.)

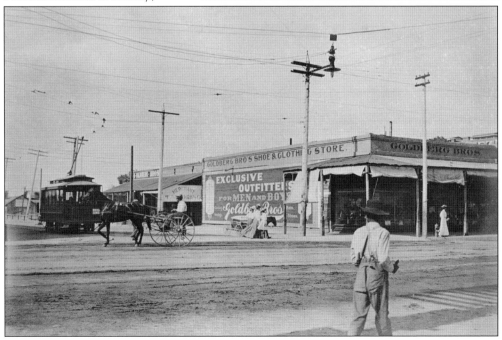

George H. N. Luhrs came to Phoenix in 1878, opening a blacksmith and wagon shop on the northeast corner of Central and Jefferson Streets. In 1887, Luhrs opened the Commercial Hotel on the site of his blacksmith shop. The original hotel was the first brick hotel in Phoenix and consisted of two stories. The hotel, below, was expanded over the years until it consisted of three stories with wide porches wrapping around two sides. Luhrs advertised the hotel as a modern hotel on the European plan with 100 rooms, a first-class restaurant, barbershop, and livery stable that rented horses and buggies. (Left, courtesy Arizona State University Libraries, Department of Archives; below, courtesy Special Collections and of the Phoenix Public Library.)

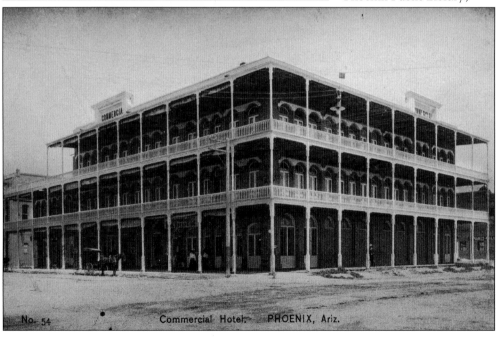

No. 54 Commercial Hotel. PHOENIX, Ariz.

Dwight B. Heard came to the Salt River Valley in 1895 for his health and became one of the valley's biggest supporters and boosters. Shortly after arriving in the area, Heard formed the Bartlett-Heard Land and Cattle Company with his father-in-law, Adolphus Bartlett. As a farmer and rancher, Heard knew the importance of water to the valley and worked tirelessly for the construction of Roosevelt Dam on the Salt River. He bought the *Arizona Republican* in 1912 to voice his ideas for the new state and ran for governor in 1924 but lost. The picture below shows Heard's original, one-story office building, in the center, on the southeast corner of Center and Adams Streets; the Adams Hotel is the large build on the left. (Right, courtesy Phoenix Museum of History; below, courtesy Phoenix Public Library.)

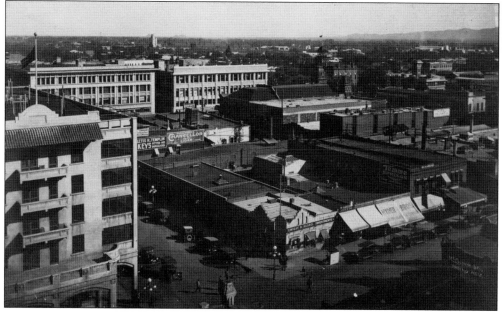

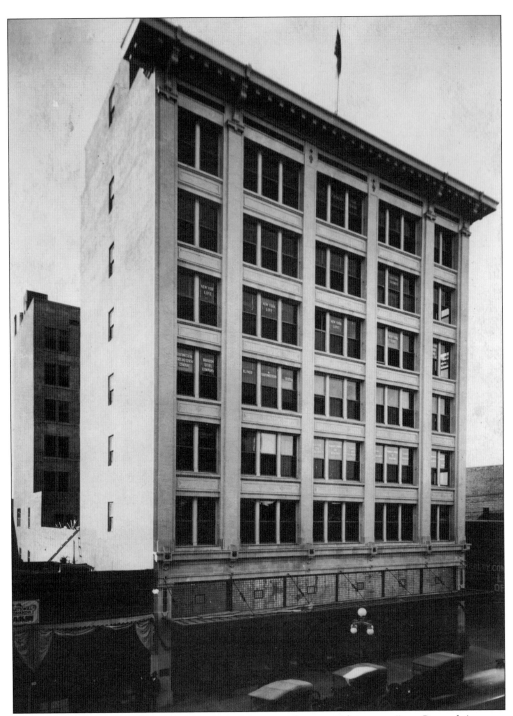

In 1918, Dwight B. Heard began construction on an eight-story "skyscraper" on Central Avenue, just north of his present office building. Completed in early 1920, the south half of the street floor housed the Dwight B. Heard Investment Company. The street floor and second floor of the north half of the building housed the *Arizona Republican*, owned by Heard, with the remainder of the building rented out as professional offices. (Courtesy Phoenix Public Library.)

Four

SCHOOLS, CHURCHES, AND A HOSPITAL

Education has always been important to Phoenix residents. The first public classes were held in the courthouse on September 5, 1871. The first schoolhouse, a one-room adobe building constructed in 1872, began holding classes on October 14, 1872, with 21 students. The number of students quickly grew, and by 1880, a two-story brick building containing four rooms was built. By 1889, construction on two more schools began on the west and east ends of the city. From that time forward, Phoenix kept building more schools for its ever-growing population of students.

On September 1, 1891, the Phoenix Indian School opened with 41 students under the direction of Hugh Patton. The school stressed agricultural and vocational training with a strong emphasis on learning English and manual labor. Located on Indian School Road and Center Street three miles north of downtown Phoenix, the school expanded rapidly until there were 800 students by 1920. The school provided a source of labor for local employers who hired the male students to work at agricultural jobs and the female students as domestics.

Religious institutions were essential to the residents of Phoenix with churches serving as social centers as much as places of worship. The first organized church in Phoenix was the Methodist Episcopal church started in 1870. Phoenix had seven churches by 1892, twenty-nine in 1916, and 59 in 1920. One observer noted Phoenix "is a city of schools, homes and churches."

For years, physicians in the East prescribed desert air for patients with respiratory problems. Phoenix with its mild, dry desert air became a "lungers' mecca" for tuberculosis patients by the early 1900s. Many sanatoriums began to open in the desert area around the Salt River Valley, most as tent camps. Phoenix's first hospital, St. Joseph's, was started in March 1895 by two Sisters of Mercy. Opening in a small house on Polk and Fourth Streets the hospital quickly expanded to meet the needs of the valley.

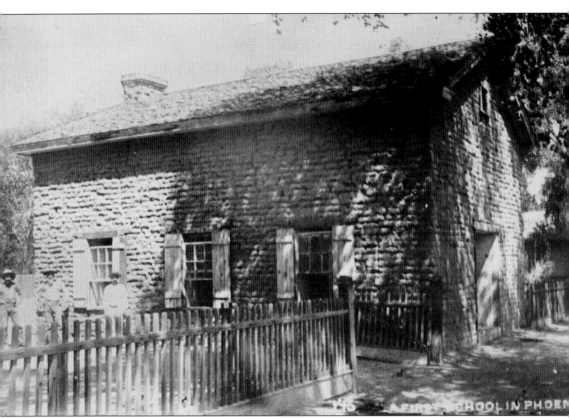

Phoenix's first schoolhouse was a one-room adobe building, 20 by 30 feet, built in 1872. School started on October 14, 1872, with J. Parker as teacher to 21 students. Ellen Shaver was the first female teacher of the Phoenix schools in 1873 at a salary of $100 a month. The number of students soon outgrew this building, and rooms had to be rented in a home across the street and at the Methodist Church South. Residents began to push the city council for a new schoolhouse. (Courtesy Arizona Historical Foundation.)

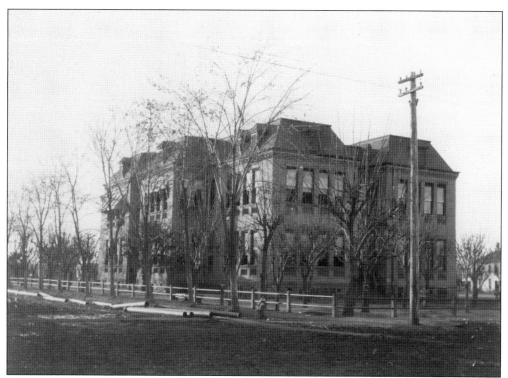

Central School (above) was opened in the fall of 1880 as a combination elementary and high school on First Avenue between Monroe and Van Buren Streets. By the mid-1880s, Phoenix had outgrown its combination elementary and high schools. In 1889, the East End elementary school was erected at Washington and Seventh Streets. In 1890, the West End elementary school (below) was erected at Madison and Seventh Avenue. Both schools were two-room brick buildings constructed for a total cost of $30,000. The schools served students from kindergarten through fourth grade. (Above, courtesy Phoenix Public Library; below, courtesy Arizona Historical Foundation.)

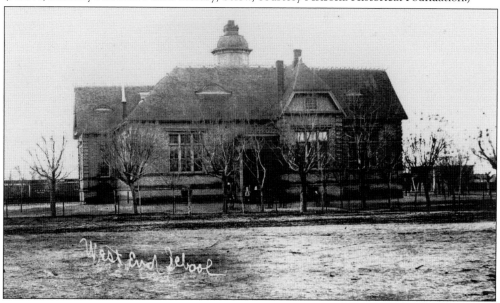

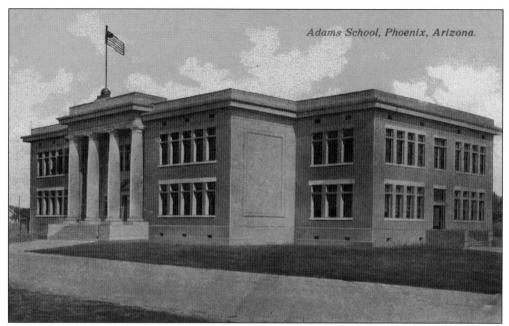

Adams School, designed in the neoclassical Revival style by Harrison Alright, was located on Adams Street between Seventh and Ninth Avenues. The school opened in 1911 and is still standing, though the name was changed to Grace Court in honor of one of the school's teachers. (Courtesy Phoenix Public Library.)

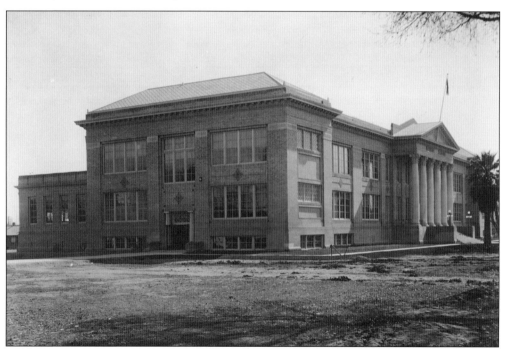

Monroe Street School at 225 North Seventh Street was another school built in the neoclassical Revival style, this time by architect Norman F. Marsh. The school opened to students in the fall of 1915 and is still standing. (Courtesy Phoenix Public Library.)

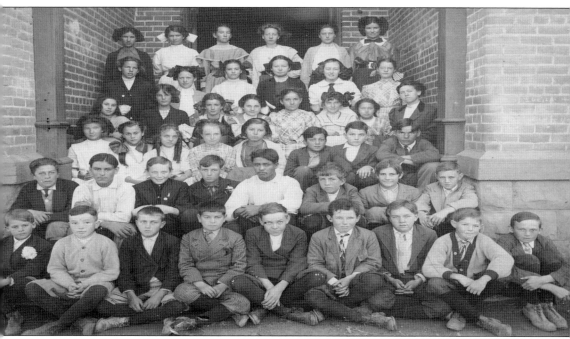

The Seventh B class of Ida McClarty's at Central High School was photographed in 1908. McClarty can be seen on the right, halfway up the stairs. (Courtesy Phoenix Museum of History.)

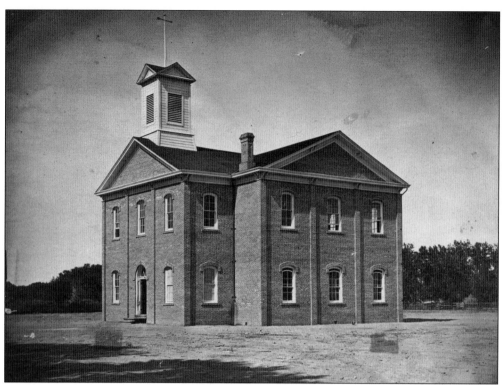

Phoenix Central High School was built in the late 1880s on Monroe Street in between Center Street and First Avenue. The school served students in grades five through seven. A full-fledged high school was not established until 1897 when the City of Phoenix bought the Clark Churchill mansion, below, on Van Buren Street between Fifth and Seventh Streets for $15,000. The high school opened in 1898 for whites only with 90 students in attendance. (Both courtesy Phoenix Museum of History.)

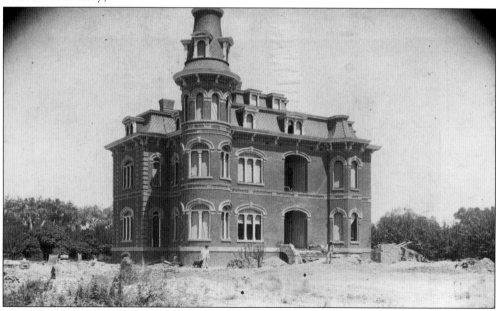

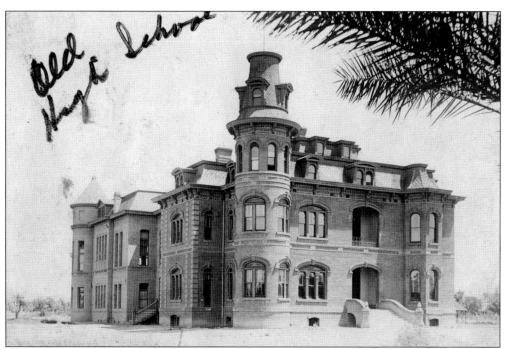

The number of students attending the new high school grew so rapidly that by the next year, 1899, a $10,000 addition had to be made to the north end of the building. This expansion can be seen in the above photograph taken in about 1900. The building remained in use until 1949 when it was demolished to make room for a modern cafeteria. (Courtesy Phoenix Museum of History.)

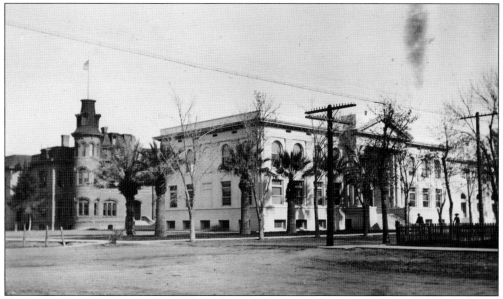

Phoenix was growing, and so was the high school; by 1910, there were 300 students enrolled in the school. In 1910, the residents of Phoenix approved a $15,000 bond issue for the construction of three new buildings. In 1912, the new domestic arts building, above, opened fronting Van Buren Street. The original school building can be seen in the background. (Courtesy Phoenix Public Library.)

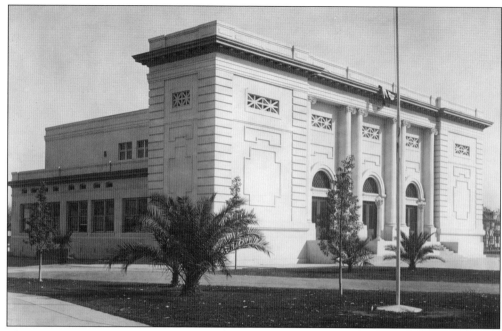

The auditorium was constructed in 1912 with money from the bond issue approved in 1910. The auditorium fronted Van Buren Street between Fifth and Seventh Avenues. Today the domestic arts, science, and auditorium buildings have been restored and are used by Arizona State University as part of their new downtown campus. (Courtesy Phoenix Public Library.)

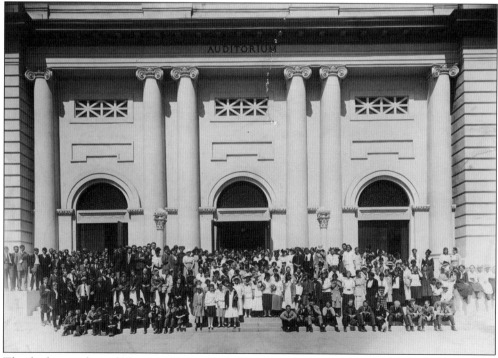

The freshmen class of Phoenix Union High School was photographed on March 20, 1917, in front of the school's auditorium. (Courtesy Phoenix Public Library.)

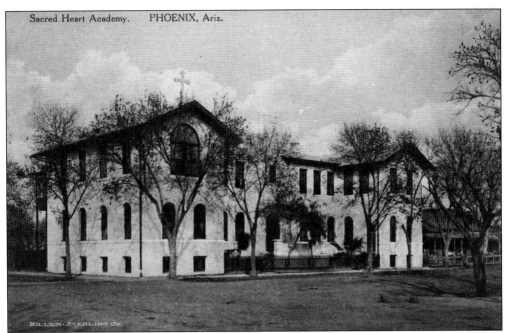

In 1892, Fr. Francis Jovenceau of St. Mary's Catholic Church asked the Sisters of Mercy in Mesilla, New Mexico, to establish a parish school in Phoenix. The sisters opened the Sacred Heart School in a small adobe building next to St. Mary's Church in 1892. In 1899, the school was put under the management of the Franciscans of St. Louis, and a new school (above) was built at Fourth Avenue and Monroe Street and renamed Sacred Heart Academy. (Courtesy Phoenix Public Library.)

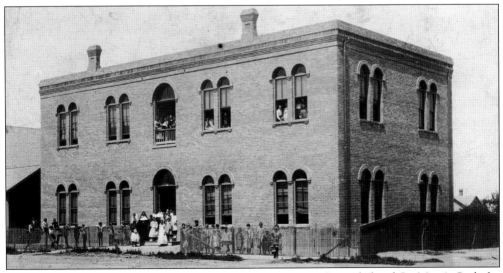

St. Mary's Catholic School was located at 410 East Monroe Street behind St. Mary's Catholic Church. The whole school must have turned out for this photograph, as there are nuns and students in front of the building and at the second-floor windows. (Courtesy Phoenix Museum of History.)

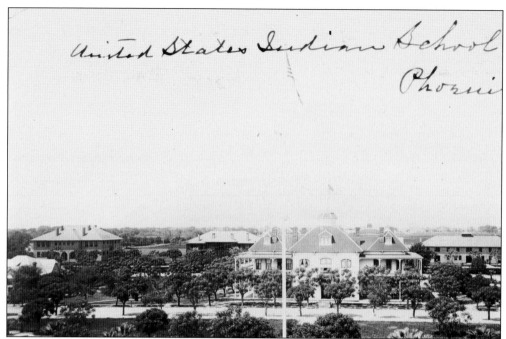

United States Indian School
Phoeni

In the 1880s, the federal government began to see Native American education as a mainstay of the assimilation program. In September 1891, Phoenix Indian School opened with 41 students in the West End Hotel on the corner of Washington Street and Seventh Avenue. Students were soon transferred to the school's first permanent building, located at Center Street and Indian School Road, in April 1892. The campus grew rapidly and in 1897 consisted of 12 buildings, 50 staff, and 380 Native American children. The photograph above was taken in the early 1900s and shows about half of the campus, including the center plaza. The girl's dormitory is the center building, classroom buildings are lined up behind the dormitory, and the water tower with the campus agricultural area behind it is to the right. (Courtesy Arizona Historical Foundation.)

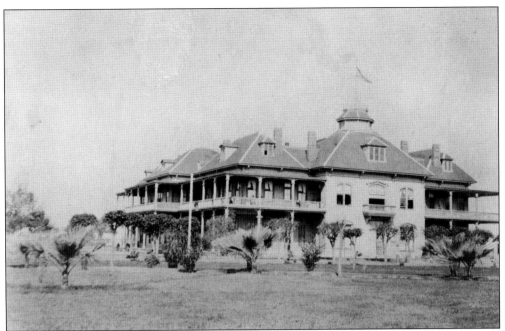

J. M. Creighton, a Phoenix architect, designed the first building on the Phoenix Indian School campus in 1892. Creighton design the building with an Italianate influence, and it became the centerpiece of the campus and one of the valley's most attractive buildings. When first completed, the building accommodated 125 students with a dormitory on the second floor and offices and classrooms on the ground floor. As more buildings were completed, the building became the girl's resident hall. (Courtesy Phoenix Museum of History.)

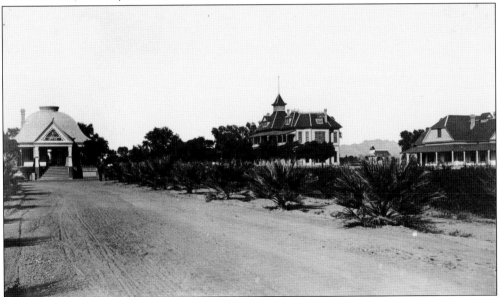

At the end of the main entrance of the Phoenix Indian School campus is the school's office building with the boy's dormitory on the right, both completed in 1895. The buildings to the far right are unidentified though are thought to be employee housing built at the same time as the office and dorm. (Courtesy Arizona Historical Foundation.)

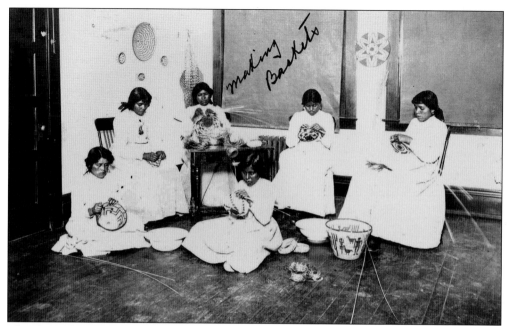

The above photograph shows Pima and Papago Indian girls working on baskets at Phoenix Indian School around 1914. It was unusual to see Native American girls doing this type of work, as the norm was to Americanize them with no involvement in traditional activities. The school's emphasis was on domestic training for Native American girls so they could hire out as domestic servants to town residents once their education was finished. Some Native American girls were hired out as servants while they were at the school, providing Phoenix residents with economical labor. The school was happy to see their students as productive members of the town. (Courtesy Arizona Historical Foundation.)

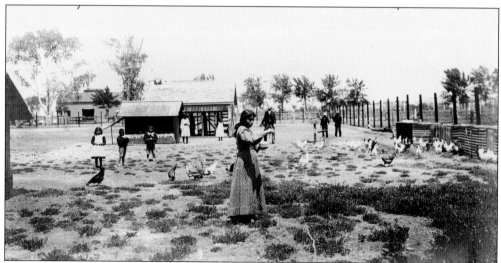

Phoenix Indian School became very self-sufficient with 240 acres under cultivation and a stockyard that housed cattle, horses, mules, pigs, and chickens. All students were expected to help with the farm and stockyard. Here a young girl is feeding chickens while other students and employees watch. Note the Americanized clothing the children are wearing with some girls in clean, white aprons. (Courtesy Arizona Historical Foundation.)

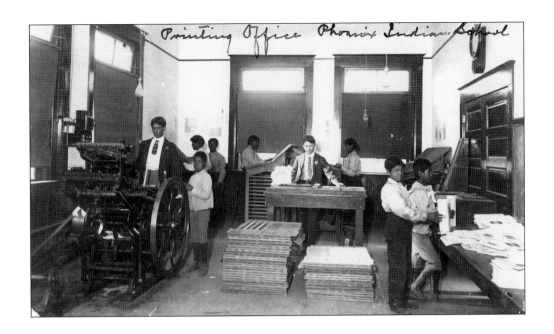

Federal officials praised superintendent Harwood Hall for his philosophy that once students finish school they "will have to make their living by the 'sweat of their brow', and not their brains." Because of this philosophy, the school operated many vocational departments such as printing, tailoring, carpentry, and shoemaking rather than educational programs. The photograph above shows boys of all ages working in the school's print shop. The tailor shop below consists of both boy and girls. Note the teacher standing in the center of the room with a boy measuring another boy as others iron, and both boys and girls sew. (Courtesy Arizona Historic Foundation.)

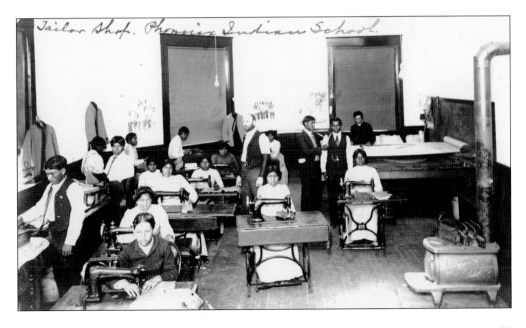

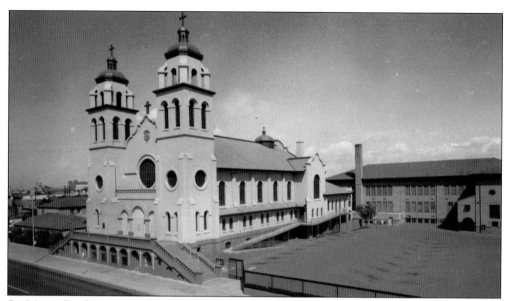

St. Mary's Basilica is the oldest Catholic parish in the valley, founded in 1881 and staffed by Franciscan friars since 1895. The church was completed in 1914 in the mission Revival style, while the inside has a decidedly Romanesque quality. The church was dedicated in 1915, declared a national historical monument in 1978, and designated a basilica by Pope John Paul II in 1985. The church is noted for its stained-glass windows, which were created by the Munich School of stained-glass art and installed at the time of construction. The photograph above was taken in 1916 with St. Mary's School on the right. (Courtesy Phoenix Museum of History.)

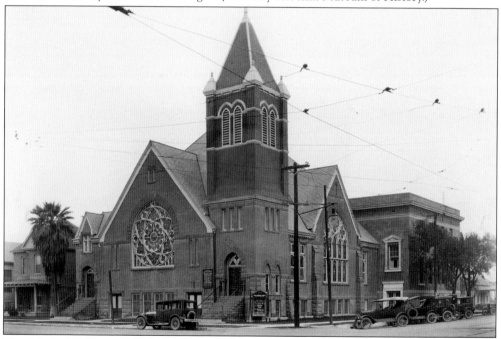

The Methodist Episcopal church on the corner of Second Avenue and Monroe Street was organized in 1874 by the Reverend G. A. Reeder. The above building was built in 1895 when the first church became too small. (Courtesy Phoenix Museum of History.)

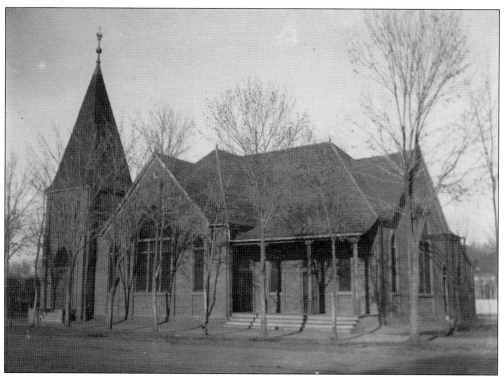

The Phoenix Christian Church, shown in a photograph from the 1890s, was located at Jefferson and Second Streets. (Courtesy Phoenix Museum of History.)

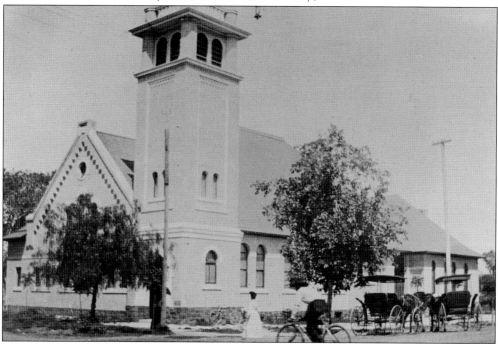

This photograph of an unidentified Phoenix church was taken in the 1890s. Phoenix had seven churches by 1892. (Courtesy Phoenix Museum of History.)

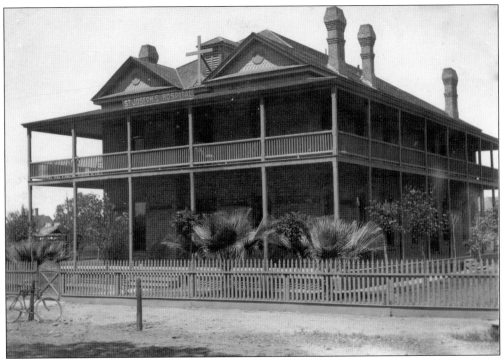

St. Joseph's Hospital was started in January 1895 as a sanitarium for tubercular patients by two Sisters of Mercy from St. Mary's Catholic School. The hospital began in a six-bedroom, brick home on the northeast corner of Polk and Fourth Streets. Two months after opening, the hospital found it necessary to expand, and by the fall of 1894, a two-story, 24-room hospital was in full operation. The hospital began taking surgical patients in 1898. By 1900, another addition to the hospital (below) was needed at the cost of $10,000, which included a new operating room, chapel, utility rooms, kitchen, and private rooms and wards. (Both courtesy Phoenix Public Library.)

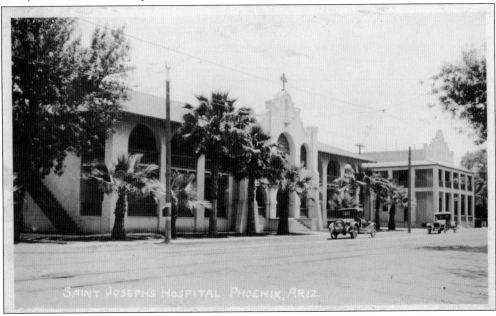

Five

A SOCIAL AND CULTURAL PHOENIX

Phoenix residents worked hard to have the same cultural and social amenities they left behind in the East. The first Christmas celebrated in the new town site of Phoenix included a ball. Phoenix residents loved parades, and from the many pictures that exist, parades must have been held a number of times each year. As the town and its residents began to prosper, men and women had more time to devote to civic and cultural endeavors. In 1900, the Phoenix Women's Club was formed with 10 members who came together to stimulate the cultural development of its members. The club women began by studying anthropology, but by the end of the first year, the club's membership was expanded, and the mission was changed to include active interest in the general cultural and civic development of Phoenix. The women secured $25,000 from Andrew Carnegie to construct a library building in 1908. The Women's Club broadened its civic campaign by becoming a member of the chamber of commerce with members on five committees watching over city sanitation, parks, and playgrounds; they were active in school elections and building programs.

The men of Phoenix were also involved in civic and cultural endeavors of the city. By 1900, Phoenix had three theaters, the Phoenix Country Club, the Arizona Club, and Fraternal Lodges and clubs. In 1893, the Young Men's Christian Organization was organized by Phoenix businessmen. These organizations worked to promote Phoenix as a city with all the amenities found in the East.

Phoenix Women's Club, built in 1911 on the northeast corner of Fillmore Street and First Avenue, was designed by Royal Lescher in the mission Revival style, which was popular at the time. The building was later demolished to make room for an addition to the Hotel Westward Ho. (Courtesy Phoenix Public Library.)

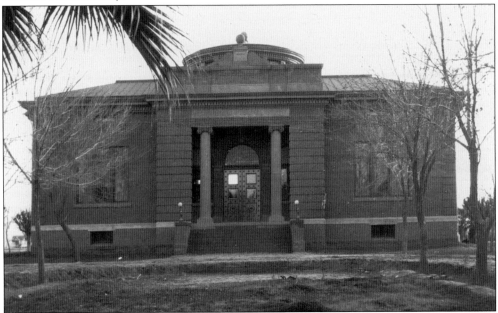

Industrialist and philanthropist Andrew Carnegie donated $25,000 for the construction of the Carnegie Public Library at Eleventh Avenue and Washington Street. Built of brick over a stone foundation, the building consisted of 10,200 square feet on two levels and held over 7,000 books when it was dedicated on February 14, 1908. The building is still standing and houses the Arizona Women's Hall of Fame. (Courtesy Phoenix Public Library.)

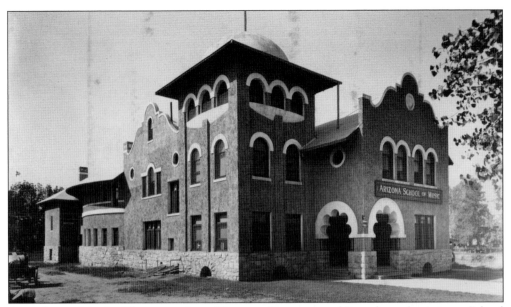

According to Marsha Weisiger, author of *Boosters, Streetcars, and Bungalows*, the Arizona School of Music was founded by Abilena Creighton Christy in 1904 to meet the "wishes of the ladies of Phoenix's 'high society' to have a school in which the fine points of culture would be taught." The school originally met in the Home Savings Bank Building until the above building was completed in 1907 at 410 North Center Street. Classes were offered in vocal and instrumental music, music theory, elocution, dancing, physical culture, and language. (Courtesy Phoenix Public Library.)

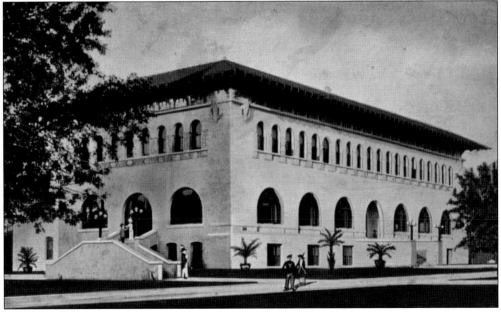

The Young Men's Christian Association was organized in Phoenix in 1893 by many of Phoenix's most prominent men. In April 1907, a campaign was organized to raise funds for a permanent structure. The organizer hoped to raise $60,000, but the final amount, raised in just 11 days, was $102,053. The building, of the mission Revival style, was dedicated on March 1, 1910, at Monroe Street between First and Second Avenues. (Courtesy Phoenix Public Library.)

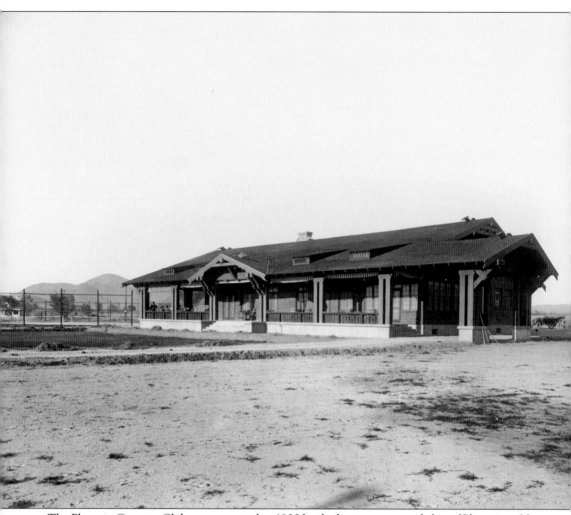

The Phoenix Country Club was organized in 1900 by the businessmen and elite of Phoenix at Van Buren Street and Seventeenth Avenue as a golf club. In 1901, the handsome clubhouse (above) was completed. The ladies of Phoenix oversaw much of the construction with logs obtained in Prescott; the clubhouse was formally dedicated on January 1, 1901. The club became the city's social and recreational center with yearly golf and tennis tournaments open to the public. The club remained at the above location until 1910 when it moved to North Center Street and the Arizona Canal. (Courtesy Arizona Historical Foundation.)

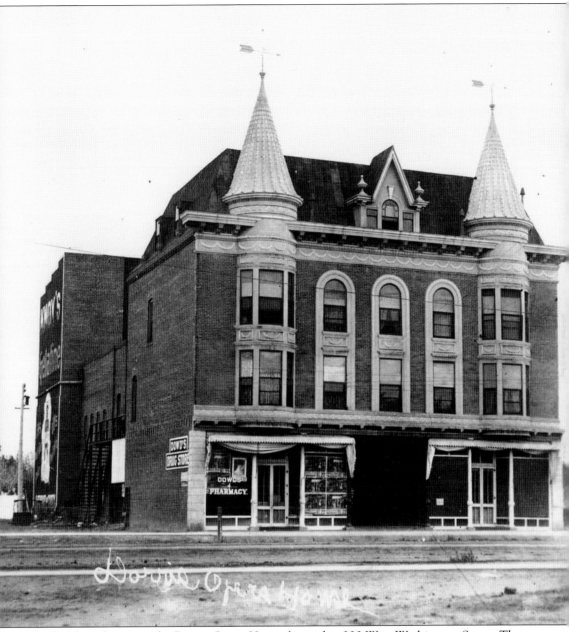

The building above was the Patton Opera House, located at 300 West Washington Street. The original architect/owner was S. E. Patton, who constructed the building in 1896 for an estimated $35,000. Built in the ornate Queen Anne style, the theater featured a pair of conical towers, almost 20 complementary bay windows, and could accommodate 1,200 patrons. The theater's grand opening was held on November 2, 1898, with a presentation of *At Gay Coney Island* playing to a sold-out audience. On December 29, 1899, Patton sold the theater to E. M. Dorris, and it was renamed the Dorris Opera House. In the 1910s, the name was changed again to the Elks Theater. The theater played host to many theatrical presentations, from Gilbert and Sullivan's *H. M. S. Pinafore* to John Phillip Sousa in 1915. The building was torn down in 1985. (Courtesy Arizona Historical Foundation.)

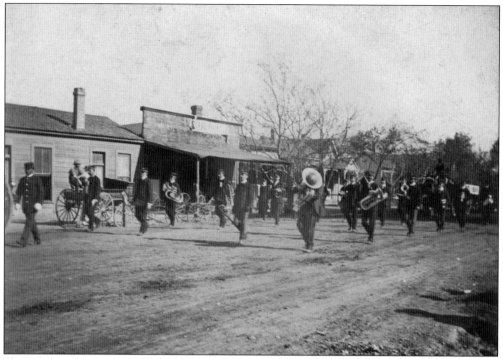

Phoenix loved a parade and held them on many occasions. The parade above was on Washington Street in the early 1880s. (Courtesy Phoenix Museum of History.)

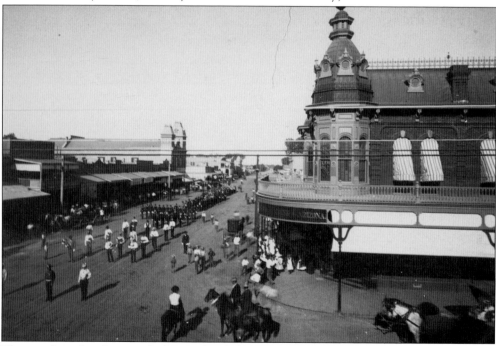

The parade in the photograph above is headed west on Washington Street at the intersection of Center Street. The Queen Anne–style Cotton Building is on the right with a large crowd on the sidewalk fronting Washington Street. (Courtesy Phoenix Museum of History.)

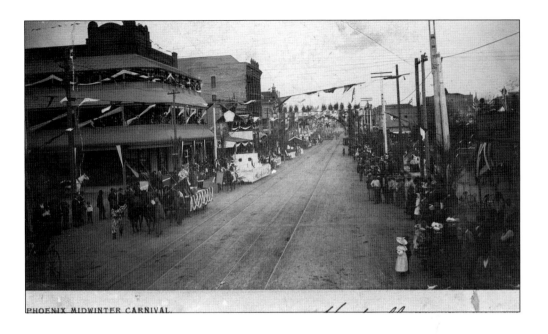

PHOENIX MIDWINTER CARNIVAL.

Phoenix held a Midwinter Carnival each year in February; the photograph above shows a number of floats parading down Washington Street in front of the Ford Hotel in 1896. The photograph below was taken during the same parade showing Phoenix Indian School students. (Both courtesy Phoenix Museum of History.)

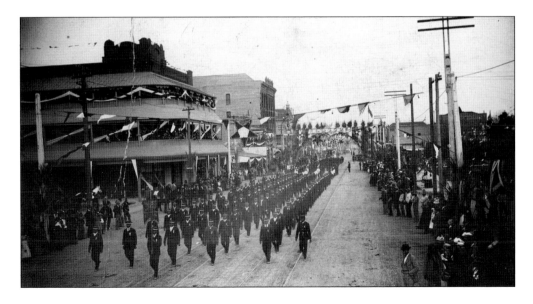

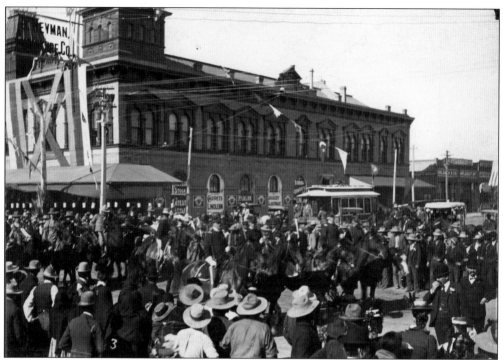

The Arizona Rough Riders often rode in Phoenix parades; here they are riding in a parade in 1901 on Washington Street. This parade was possibly for Pres. William McKinley who visited Phoenix in May 1901. (Courtesy Phoenix Public Library.)

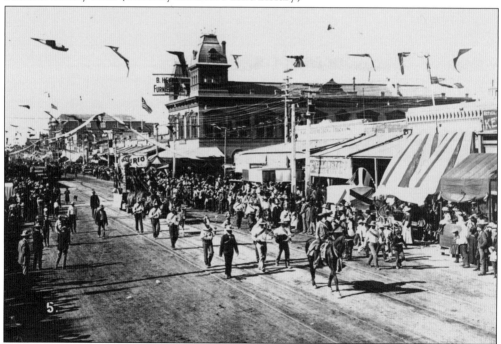

Yaqui musicians and dancers are lead by an officer of the Rurales from Sonora, Mexico, in this 1908 parade down Washington Street. (Courtesy Arizona Historical Foundation.)

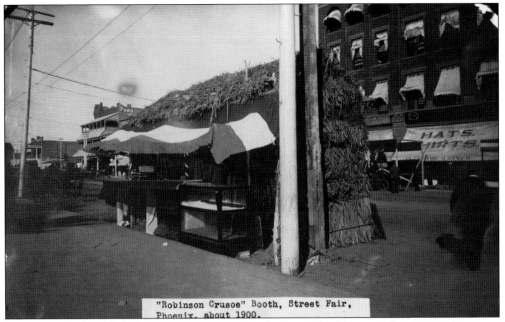

This photograph is labeled " 'Robinson Crusoe' booth, Street Fair, Phoenix, about 1900." (Courtesy Phoenix Public Library.)

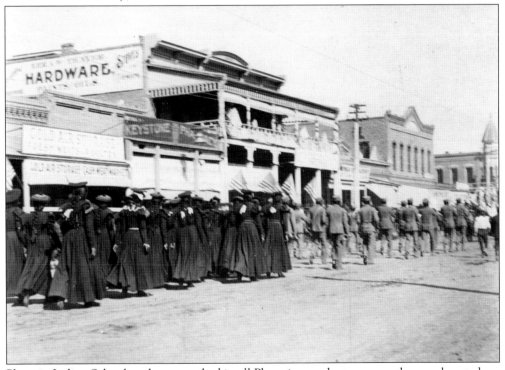

Phoenix Indian School students marched in all Phoenix parades to expose the populous to how civilized the students had become. In the above photograph, girls from the school are marching down Washington Street during the Midwinter Carnival in 1896. (Courtesy Phoenix Museum of History.)

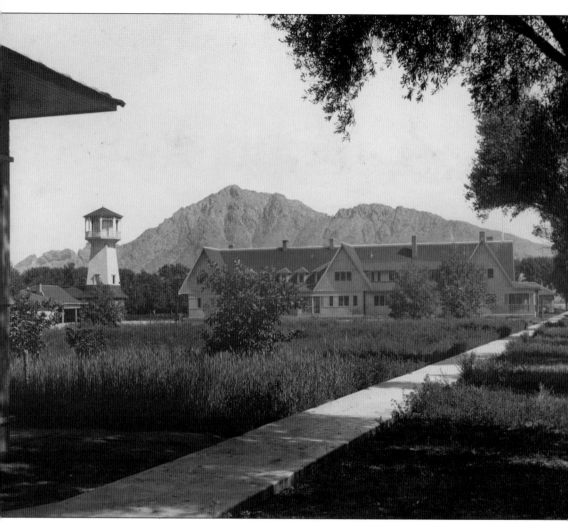

The Ingleside Club, located eight miles northeast of Phoenix, was built in 1909 by W. J. Murphy as a private club to entertain potential investors. The Ingleside is considered the first winter resort built in Phoenix and consisted of a clubhouse, golf course, and cottages for visitors. Besides golf, the club provided tennis, horseback riding, mountain climbing, and picnics at Echo Canyon on the north side of Camelback Mountain. In 1921, Ralph Murphy, W. J.'s son, changed the name to the Ingleside Inn and opened it to the public. The Murphy family lost the inn in 1932 because of the Depression. Today the Arizona Country Club sits on the site. (Courtesy Phoenix Public Library.)

Six

WOMEN AND HOMES
OF PHOENIX

Phoenix residents planted cottonwood trees along the streets and around their lots as soon as the town site was laid out, giving the town a green and productive appearance. Planting trees along the streets continued through the years with Phoenix leaders urging citizens to "grow grass and plant flowers" in "the city of trees" in the middle of a desert. William J. Murphy alone planted over 400 trees along north Center Street.

New residential developments sprang up all around the city. In the 1890s, the place to live was along east Monroe Street from Center to Seventh Streets. In the 1900s, Center Street, north of Van Buren Street, became the area where lovely mansions went up. While the elite built homes along Monroe and Center Streets, the average Phoenix resident bought his home in one of the new developments showing up east and west of Seventh Street and Seventh Avenue. These developments grew quickly as the street railway expanded to the new areas of the city, giving residents easy access to downtown.

Women and men came to the Salt River Valley to make their homes and help the community grow. Many women worked alongside their husbands farming, running businesses, and building a community. Adeline Gray and Julia Lount were two of the first to come to the valley. Laura Murphy was her husband's eyes and ears during the building of the Arizona Canal, and Josephine Goldwater was a nurse caring for tuberculosis patients when she came to the valley. Josephine loved sports and was one of the first women to push for a women's golf tournament at the Phoenix Country Club. Life was not easy for these women, but they built homes and raised families in the new community.

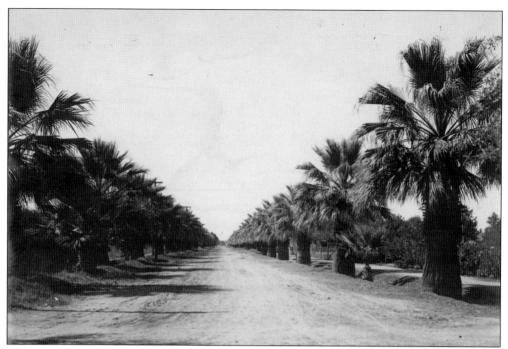

Center Street in 1900 was lined with palm trees planted by W. J. Murphy. Murphy planted more than 400 palms and other trees along Center Street to help sell his housing development in the area. (Courtesy Phoenix Museum of History.)

The photograph above is of a tree-lined residential street in 1901. A house can barely be seen behind the trees on the right. (Courtesy Phoenix Public Library.)

A fully developed residential neighborhood with concrete sidewalks and green grass is seen in this 1910s photograph. (Courtesy Phoenix Public Library.)

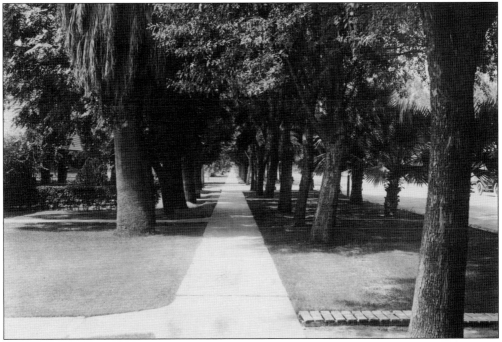

The above photograph is another view of a well-developed neighborhood with concrete sidewalks and full-grown trees for shade. Note the wood walkway from the sidewalk to the street in the foreground. (Courtesy Phoenix Public Library.)

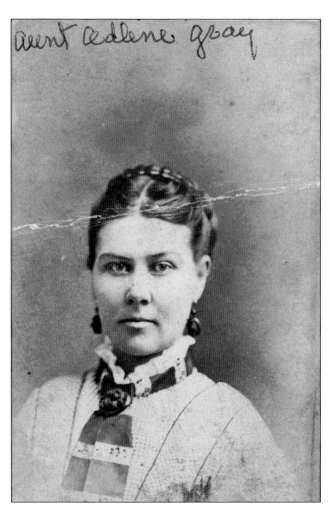

aunt adeline gray

Adeline Gray came to the Salt River Valley with her husband, Columbus H. Gray, in 1868. They homesteaded 320 acres on South Seventh Street and eventually built a stately home in 1890. Adeline is often thought to be the first Anglo woman to settle in the valley. The photograph below shows Columbus and Adeline in front of their home with their two African American servants who came to the valley with the Grays. (Both courtesy Phoenix Museum of History.)

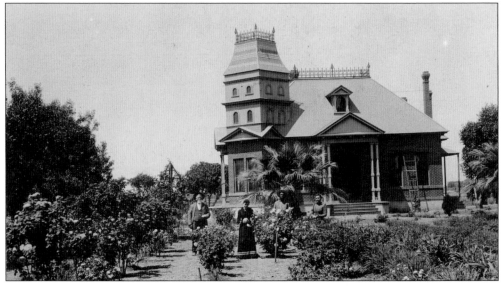

Julia Lount came to Phoenix from Prescott in 1878 with her husband, Samuel, and two children. Samuel built the first ice plant in Phoenix, which began operations on June 17, 1879. Julia was a member of the Phoenix Women's Club and very active in civic affairs. In the photograph below, Julia is standing in front of her home at 306 North Second Street, a home she lived in from the early 1880s until her death on April 27, 1907. (Both courtesy Phoenix Museum of History.)

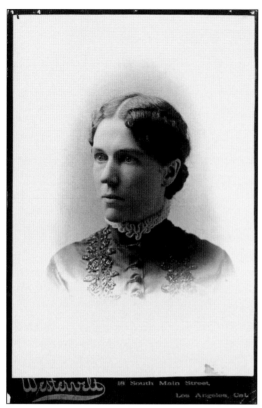

18 South Main Street,

Los Angeles, Cal.

Ellen Shaver was Phoenix's first female teacher, a position she held until marrying John Y. T. Smith, who is considered the first resident of the Salt River Valley. He served two terms in the territorial legislature and owned the second flour mill in Phoenix. The Smiths had four children—two boy and two girls. Their oldest child, William, died of measles in 1883 when an epidemic swept through the valley. In 1892, Smith built a large, two-story, brick home, below, for his family at 500 East Adams Street. (Above, courtesy Arizona Historical Foundation; below, courtesy Phoenix Museum of History.)

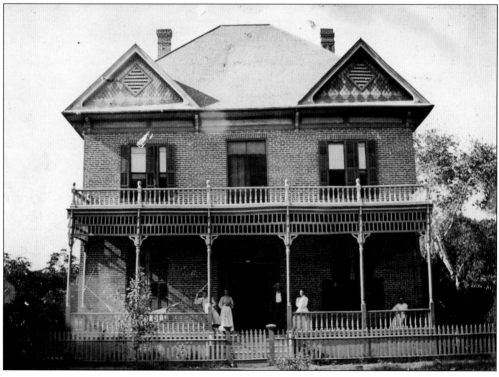

Laura Fulwiler married William J. Murphy in 1874 in Lexington, Illinois, and bore him four children. In 1880, W. J. took a contract to grade the Santa Fe Railroad line through Flagstaff, Arizona. Laura accompanied her husband to Flagstaff and then to Phoenix in 1883 when he contracted to build the Arizona Canal. The canal company ran out of money, and W. J. took it on himself to raise the funds needed for completion. While W. J. was in the East, Laura and her brother W. D. Fulwiler supervised the building of the Arizona Canal; Laura kept W. J. informed through weekly letters. Laura and her children lived at the construction camp until the canal was completed in 1885. Laura's hard work and sacrifices paid off when W. J. built her a beautiful Queen Anne home, below, in 1896 on Center Street and Orangewood Avenue. The two ladies in the photograph are unidentified. (Right, courtesy Phoenix Museum of History; below, courtesy Arizona Historical Foundation.)

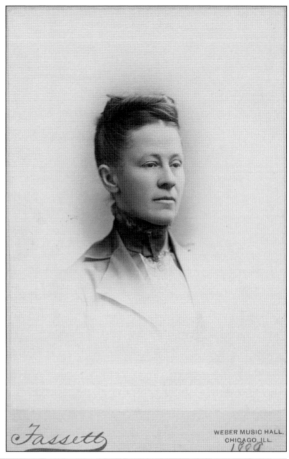

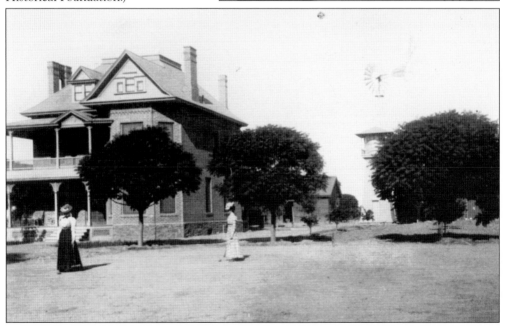

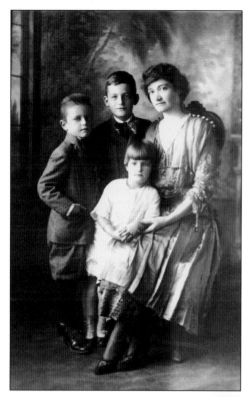

Josephine Williams was a nurse from the Midwest who came to Phoenix in 1903 because of health issues. Josephine was in Phoenix only a short time when she met Baron Goldwater, a confirmed bachelor. Goldwater waited on Josephine in his department store, M. Goldwater and Brothers, and was immediately intrigued with her; they were married on New Years Day 1907. The Goldwaters had three children, Barry, Robert, and Carolyn, who are pictured with their mother, Josephine. Barry Goldwater served Arizona in the U.S. Senate for five terms and ran for president in 1964 on the Republican ticket. The Goldwaters bought their home at 710 North Center Street shortly after their marriage; all three of their children were born there. The home is second to the right in the photograph below. (Both courtesy Arizona Historical Foundation.)

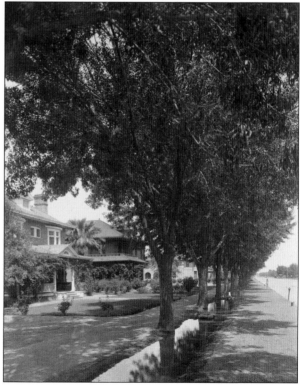

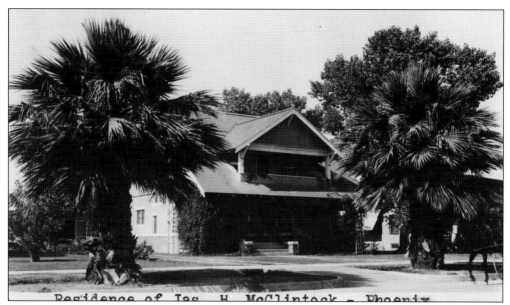

Residence of Jas. H. McClintock - Phoenix

The home of James H. McClintock and his wife, Dorothy, is a one-and-a-half story bungalow built in 1911 at 323 East Willetta Street. The McClintock's bought the home in 1913 and lived there until 1934. McClintock was Phoenix's postmaster for 13 years and Arizona correspondent for the *Los Angeles Times* from 1899 until 1934. Dorothy McClintock was a prominent botanist from Sanford University and was very active in the Phoenix Women's Club and other civic organizations. (Courtesy Phoenix Public Library.)

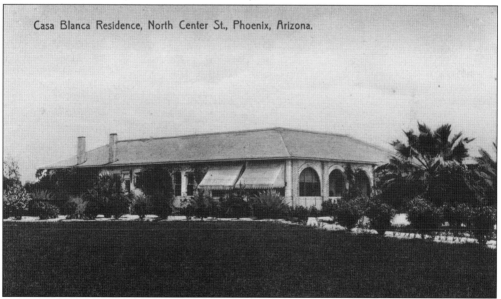

Casa Blanca Residence, North Center St., Phoenix, Arizona.

In 1902, Dwight and Maie Heard built a 6,000 square foot home called Casa Blanca at 1901 North Central Avenue, which was to become part of Heard's Los Olivos development. The home featured Spanish-style architecture and was built around an open courtyard. Heard and his wife, Maie, were avid collectors of Native American artifacts, building a museum on property adjacent to their home in 1929. Today the Heard Museum is internationally recognized for the quality of its collections of Native American artifacts. (Courtesy Phoenix Public Library.)

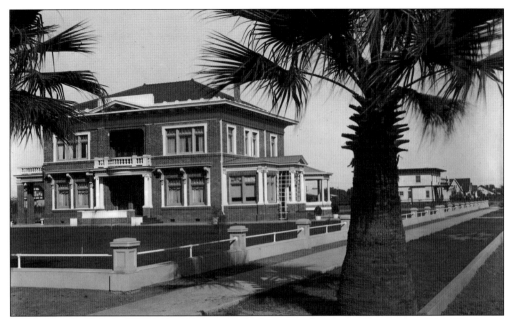

Edward Eisele, founder of Phoenix Bakery, built the home shown on this page in 1914. The home was part of the Los Olivos subdivision developed by Dwight B. Heard and has characteristics of the popular prairie style of the time. Eisele sold the home to Isaac Diamond in 1929. Diamond and his brother Nathan owned and operated the Boston Store in downtown Phoenix. Nellie Diamond lived in the home until 1959. The home was demolished in 1961 to make way for an office building. The photograph above was taken shortly after the house was built in 1914 with no landscaping, while the photograph below shows the home six years later with a perfectly manicured yard. (Both courtesy Phoenix Public Library.)

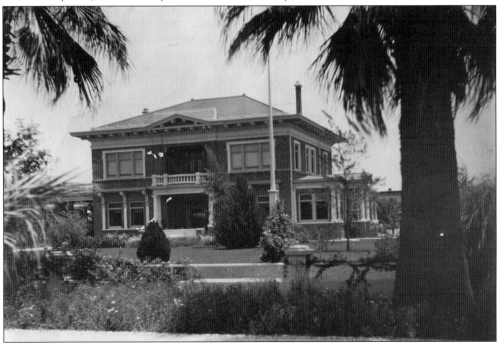

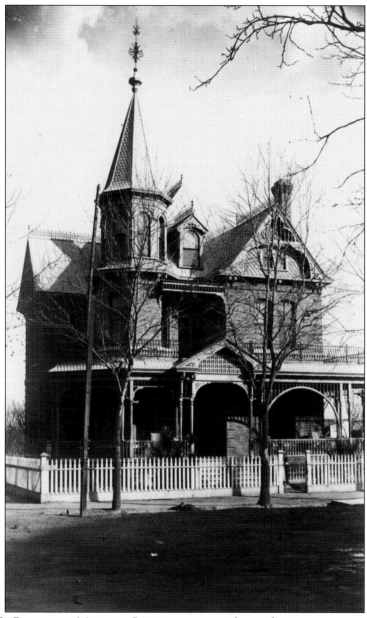

Dr. Roland L. Rosson was Maricopa County coroner and served two terms as county treasurer before being elected mayor of Phoenix in 1887. Rosson built this stately home in 1895 at 139 North Sixth Street for $7,500. The home is one of the best examples of Eastlake architecture in Phoenix with its spindle work, decorative porches, and an octagonal turret with elaborate finial and spool-like ornamentation on the third floor. Inside the first floor has parquet flooring, red glass transoms, and tin ceilings. Designed by A. P. Petitt, one of Phoenix's most influential architects, and built by contractor George Cisney, the house was one of the first brick homes in Phoenix. The Rossons lived in the house for two years before selling it in 1898 and moving to Los Angeles. The home went through many owners and served as a boardinghouse for many years. Today the home has been restored, for $750,000, to its original grandeur and is open for tours at Heritage Square in downtown Phoenix. (Courtesy Arizona Historical Foundation.)

Aaron Goldberg, partner in the Goldberg Clothing Store in downtown Phoenix, built this home for his family in the early 1890s at 510 East Monroe Street. (Courtesy Phoenix Museum of History.)

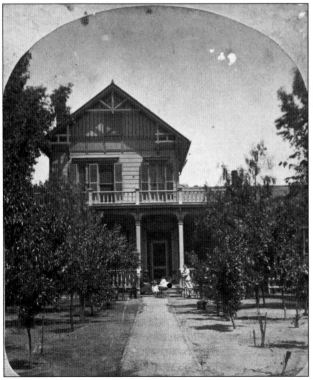

The house at 208 East Monroe Street was the home of Clark A. and Virginia Churchill. Churchill was a real estate developer who built a large mansion in 1895 on Van Buren Street between Fifth and Seventh Streets. Financial problems required Churchill to sell the mansion before its completion to the City of Phoenix for a high school. Churchill died shortly after the sale, and Virginia continued to live in the above home until her death on May 1, 1919. (Courtesy Phoenix Museum of History.)

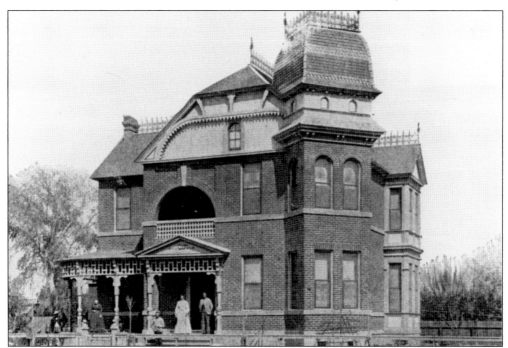

John T. Dennis built the above home in 1887 at Monroe and Third Streets on land Dennis eventually developed into a residential subdivision. The home was built in the Queen Anne style of the time and was razed in 1952. Today the Herberger Theater stands where this beautiful home once stood. (Courtesy Phoenix Museum of History.)

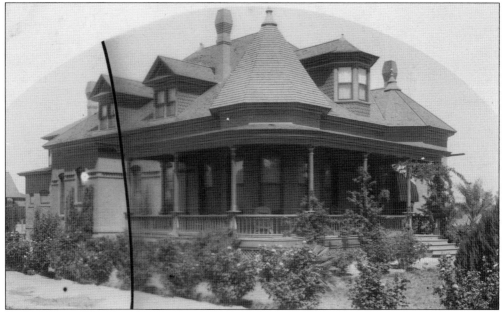

E. J. Bennitt was a civic leader, banker, and real estate investor when he built this Queen Anne–style home in 1896 at 620 North Center Street. The home was designed by Fred Heinlein, a local architect. It was demolished to make way for the Hotel Westward Ho in the late 1920s. (Courtesy Phoenix Public Library.)

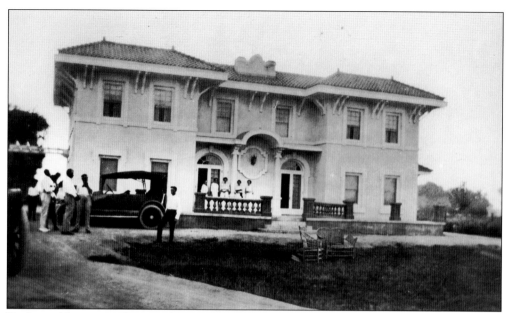

Dr. James Norton, professor and Arizona veterinarian, built this mission-style residence for his wife and children in 1912. The house was situated in the middle of Norton's 200-acre dairy farm at 2700 North Fifteenth Avenue. In the 1930s, Dr. Norton began selling portions of his property to the City of Phoenix for Encanto Park. Today the house is used as offices for the Phoenix Parks Department. (Courtesy Phoenix Public Library.)

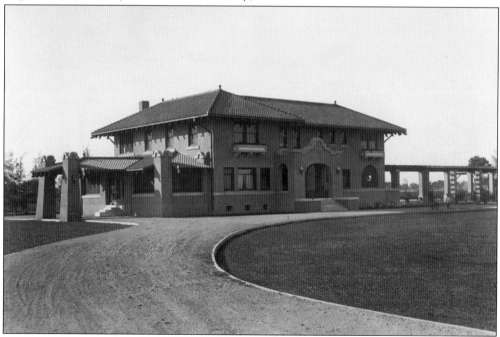

Joseph W. Dorris ran a large wholesale and retail grocery business known as J. W. Dorris Cash Grocery in downtown Phoenix. In 1911, Dorris constructed the above home, named Casa de Rosa, in the mission style at 3040 North Seventh Avenue. Today the home is part of Good Sheppard Lutheran Church. (Courtesy Phoenix Public Library.)

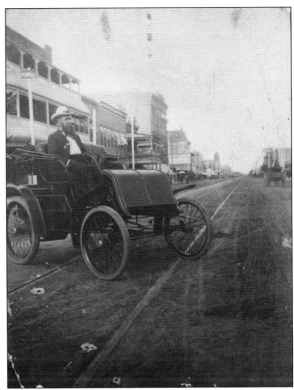

Dr. J. M. Swetnam, a Phoenix physician and surgeon, is purported to have brought the first automobile to Phoenix in 1902. The automobile, a 1901 Winton, is pictured at right with Dr. Swetnam at the wheel in the intersection of Second Avenue and Washington Street. The photograph below shows the home Dr. Swetnam purchased in 1908 at 1748 West Adams Street. The home was built in 1897 in the Capital subdivision, named for the territorial capitol, which was built at 1700 West Washington Street in 1899. (Both courtesy Phoenix Museum of History.)

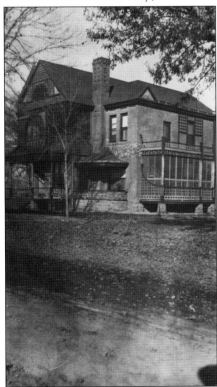

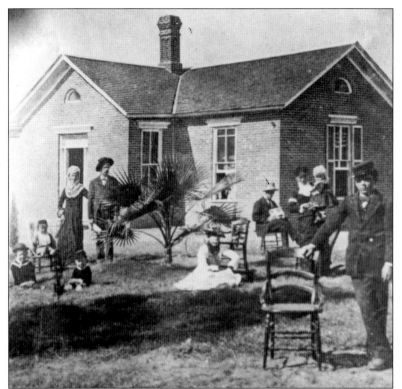

The Lemon family was photographed in front of their home in 1880. The caption on the photograph says the bricks and lumber for the home came from Los Angles. The people in the photograph are referred to as "Grandpa" and "Grandma" on the left, "Papa" sitting in a chair, and Lawrence standing on the right. The others in the photograph are unidentified. (Courtesy Phoenix Museum of History.)

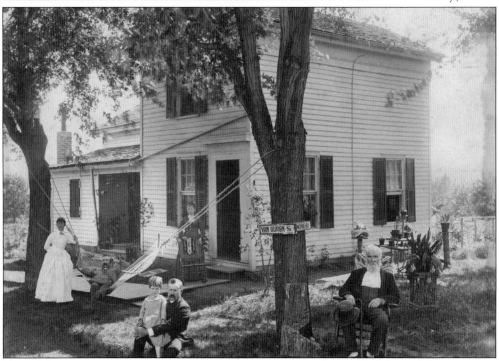

The Stinson family lived at Fourth and Van Buren Streets in 1879. The entire family must have come outside to sit for the above photograph. (Courtesy Phoenix Museum of History.)

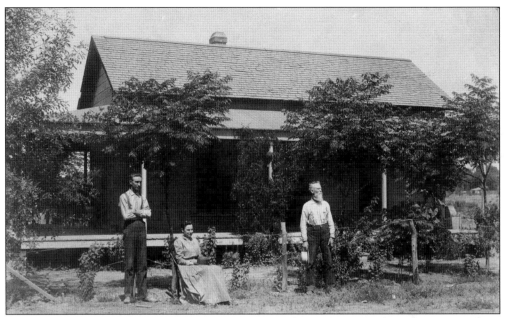

D. S. Bewley was a freighter in Phoenix and had a nice home for 1880s Phoenix on East Adams Street between Eighth and Ninth Streets. Bewley is on the right in the above photograph; the other man and woman are unidentified. (Courtesy Phoenix Museum of History.)

George Cisney and his granddaughter Gracie stand in front of their home at 228 East Jefferson Street. George Cisney and his son Claude ran a construction company from a shop behind the home. (Courtesy Phoenix Museum of History.)

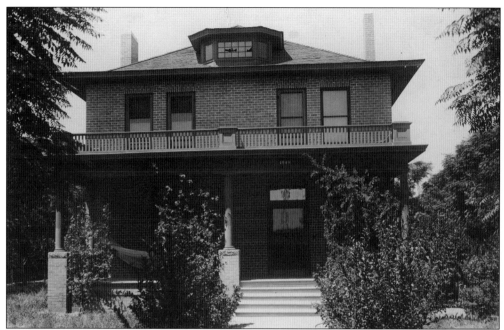

Lloyd Christy's home in 1905 was at 1026 North Center Street. Christy and his family lived in the home until 1919 when they moved to the new development, Chelsea Place. Christy was manager of the Valley Bank from 1903 to 1914, and he served on the Phoenix City Council from 1906 to 1909 when he was elected mayor of Phoenix. (Courtesy Phoenix Public Library.)

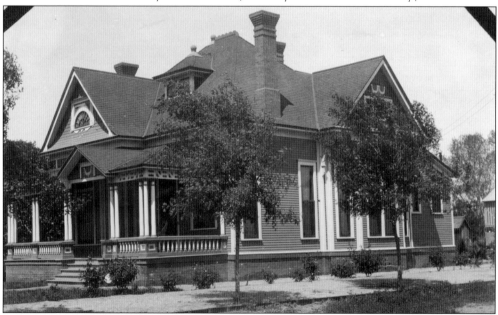

The above photograph was taken in 1899 of the Frank Cox home at 802 West Washington Street. Cox was a prominent Phoenix attorney whose clients included Southern Pacific Railroad in Arizona, Western Union Telegraph Company, and Wells Fargo Express. He served four consecutive terms as district attorney for the Arizona territory. A state office building now stands on the property. (Courtesy Phoenix Public Library.)

Seven

AGRICULTURE AND IRRIGATION IN THE VALLEY

Agriculture was important to the people of the Salt River Valley from the time the first settlers inhabited the area. The Salt River provided the water and the ancient Hohokam canals, once cleaned out, provided the means to get the water to the crops. New canals were built until there were six canal companies in the county providing water to 150,000 acres of cultivated land by 1892.

With irrigation from the many canals, valley farmers began to experiment with semitropical fruits. The first fig orchard was planted in 1887 and the first orange orchard in April 1889. The Salt River Valley became one of the country's premier areas for oranges and grapefruit. Other crops that prospered were lemons, apricots, grapes, dates, melons, and olives as well as field crops such as alfalfa, wheat, barley, and corn. Cotton, first planted in 1883, did not become a major crop for the valley until World War I.

Cattle and sheep ranching as well as dairy farming were major agricultural industries throughout the valley. Ostrich farms were big business and sprang up all over the valley beginning in 1888 for the purpose of selling the feathers to factories in the East for women's hats.

The Salt River could not be depended on to supply an even flow of water. At times, as in 1890 and 1891, the river overflowed its banks flooding the surrounding farmland, including south Phoenix to Jefferson Street. After two seasons of flooding, the valley experienced a drought that lasted through the rest of the decade. Phoenix businessmen, farmers, and ranchers decided a water storage system was needed. They formed the Salt River Valley Storage Committee to find an answer to the water problem. That answer came in the form of the nation's first reclamation project, which provided funding for the construction of Roosevelt Dam and reservoir on the Salt River.

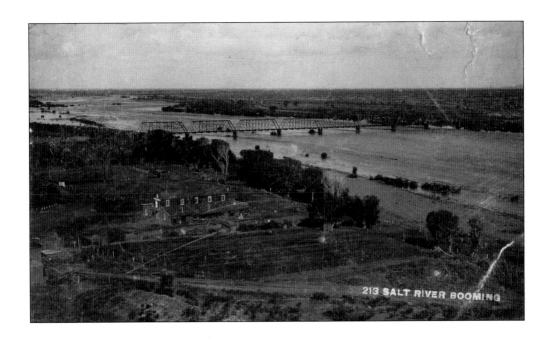

The caption on the above photograph reads "Salt River Booming," which is exactly what happened when the river was running at its normal flow. But it was another story when the river was overflowing its banks or running at a trickle during times of drought. The Salt River provided water for agriculture, city water supplies, and manufacturing. The photograph below shows the river running at full capacity on a beautiful moonlit night. (Both courtesy Phoenix Museum of History.)

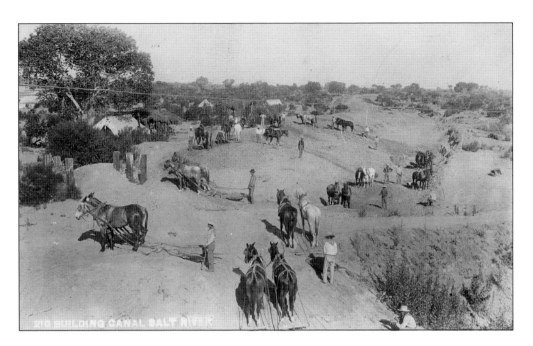

In 1882, a group of Phoenix promoters got together and formed the Arizona Canal Company. William J. Murphy was put in charge of building the canal starting at a point one mile below the confluence of the Verde and Salt Rivers. When finished in June 1885, the canal was 47 miles long, increasing the irrigated land by 50,000 acres through the northern section of the Salt River Valley. The photograph above shows the construction crew working on the canal in about 1884. The photograph below shows William J. Murphy's wife, Laura, and family standing on the head gates of the Arizona Canal in 1886. Laura Murphy is on the far left, and her brother W. D. Fulwiler is in the white shirt, others in the group, including the Murphy children, are unidentified. (Both courtesy Phoenix Museum of History.)

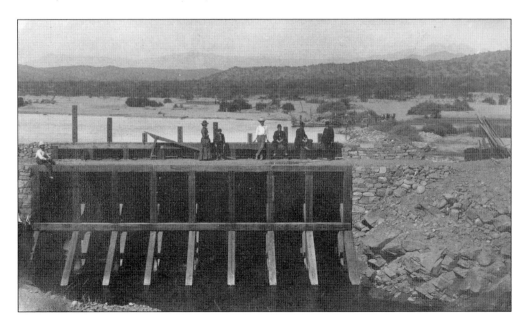

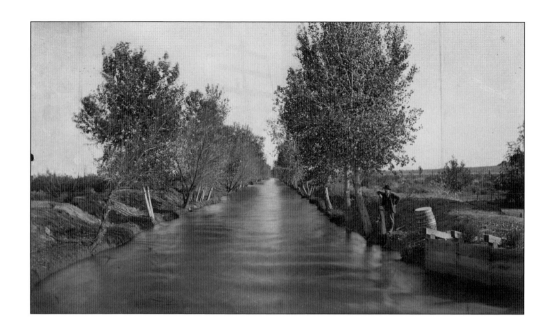

By 1890, the canal was flowing at capacity through the desert. The man above and to the right is unidentified. The photograph below was taken in 1904 showing the head gate of the Arizona Canal in all its glory. (Both courtesy Phoenix Museum of History.)

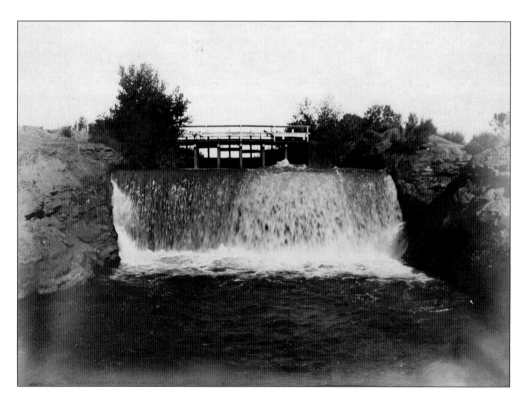

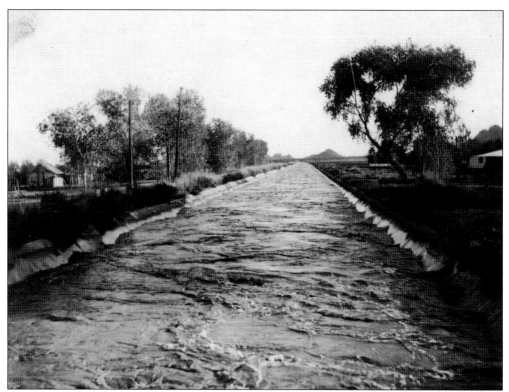

The Cross Cut Canal was built in 1888 connecting the Arizona Canal and Grand Canal along today's Forty-Eighth Street in Phoenix. The Cross Cut Canal allowed more acreage to be cultivated east of Camelback Mountain in what is today Paradise Valley. (Both courtesy Phoenix Public Library.)

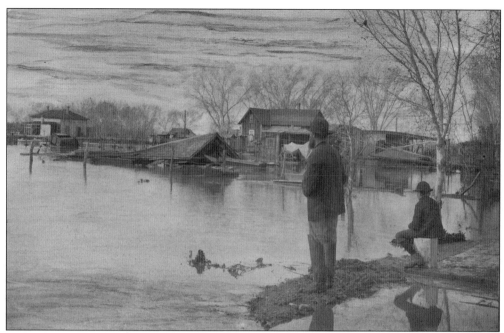

In February 1891, warm rains fell on heavy snow in the Tonto country where the Salt River begins. The river began to rise on February 15, 1891, and reached its peak on February 24, 1891. The river overflowed its banks, with floodwater reaching to the south side of Jefferson Street in downtown Phoenix. The floodwaters washed away many adobe homes in the southern section of Phoenix and ruined millions of dollars worth of crops and livestock. In the photograph above, a father and son watch as water from the Salt River floods the streets of Phoenix. The river has stopped just before reaching H. W. Ryder's Lumber Company at 113 East Jefferson Street, below, but the homes south of the lumber company were not as fortunate. (Above, courtesy Phoenix Museum of History; below, courtesy Phoenix Public Library.)

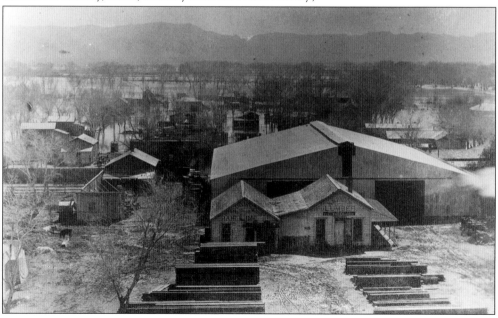

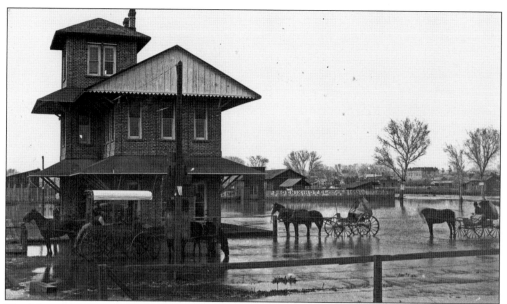

The Maricopa-Phoenix station, known as the "Blockhouse," was located at Jackson and Seventh Streets. The first train steamed into Phoenix on July 4, 1887, to a large crowd of well wishers. There was a problem; there was no way for the train to turn around. The train left Phoenix the next morning backing all the way to Maricopa. The photograph above was taken of the station during the 1891 flood, which reached to South Jefferson Street. (Courtesy Phoenix Museum of History.)

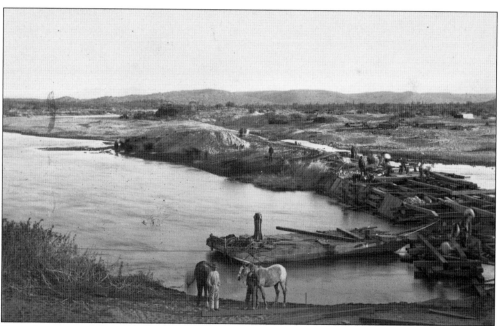

Even the Arizona Canal did not escape the devastating flood of 1891. Miles of canal were filled with mud that had to be removed before water could resume flowing. The head gates of the Arizona Canal, above, suffered substantial damage and took months to repair. (Courtesy Phoenix Museum of History.)

In 1905, Phoenix again suffered flooding when the Salt River overflowed its banks. This time the water reached to the territorial capitol building at Seventeenth Avenue and Washington Street. The capitol, above, can be seen through the trees on the left surrounded by water. The photograph below is looking east along Washington Street with young boys playing on the street railway tracks, the only dry land in the area. Note the horse and buggy on the left. (Both courtesy Phoenix Public Library.)

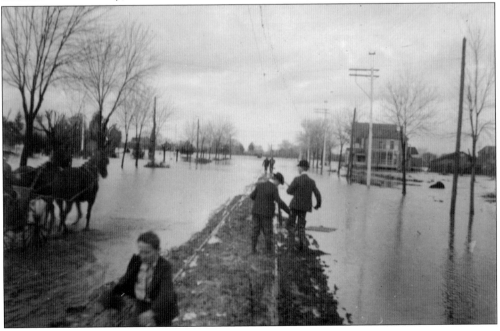

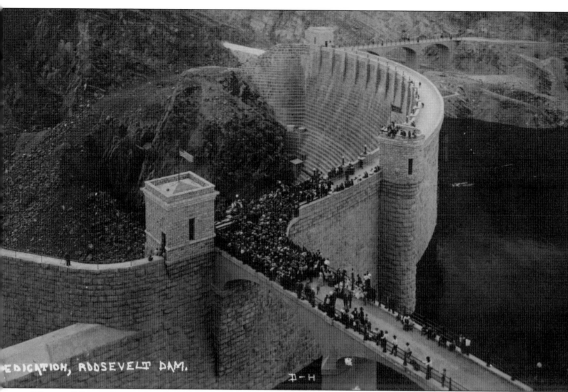

DEDICATION, ROOSEVELT DAM.

The problem of an even flow of water in the Salt River was solved when Roosevelt Dam, the first project of the Federal Reclamation Act of 1902, was finished on the Salt River in the Tonto Basin. Started in 1905 and finished in 1911, the dam provided a storage reservoir that controlled the river in times of flooding and drought. The photograph above shows the dam with a large group of Phoenicians assembled to hear former president Theodore Roosevelt dedicate the dam on March 18, 1911. (Courtesy Phoenix Museum of History.)

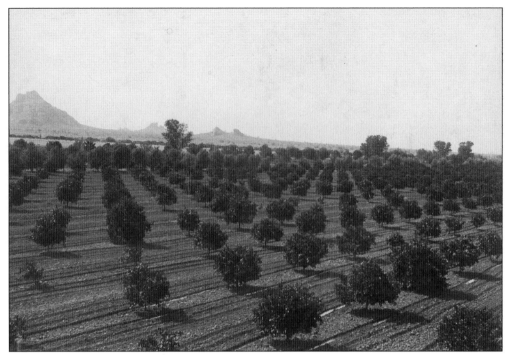

William J. Murphy planted the first orange grove in the valley in 1889 at Ingleside northeast of Phoenix. The straight rows of trees with Camelback Mountain in the distance were to become a familiar site in the valley. Murphy eventually planted 635 acres of citrus, 700 acres of apricots, peaches and almonds, 40 acres of figs, and 30 acres of olives. (Courtesy Phoenix Museum of History.)

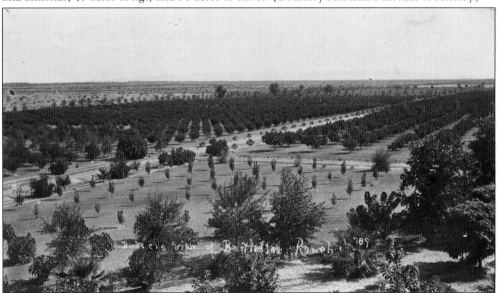

Dwight B. Heard came to the Salt River Valley for his health in 1895 and became one of the largest land owners and farmers. Heard, along with his father-in-law, A. C. Bartlett, established the Bartlett-Heard Land and Cattle Company, purchasing 1,100 acres south of the Salt River. Heard planted citrus, cotton, alfalfa, grain, and grapes. The photograph above is the start of a citrus orchard on the Bartlett-Heard Ranch. (Courtesy Phoenix Museum of History.)

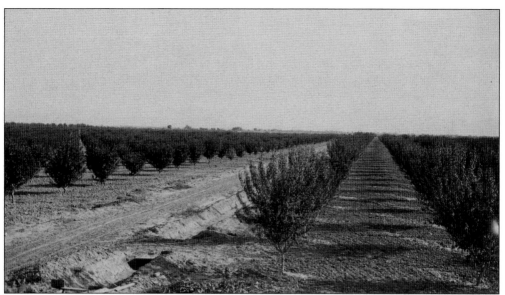

The photograph above shows a two-year-old orchard in 1890; note the irrigation ditch to the left of the center row of trees. (Courtesy Phoenix Museum of History.)

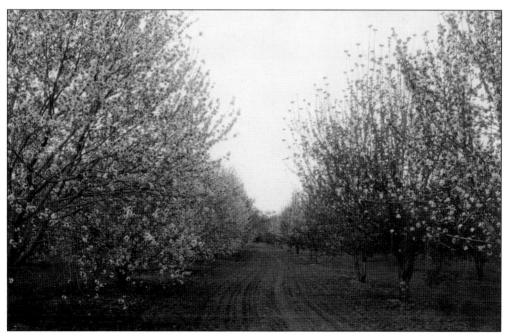

The photograph above shows a full-grown citrus orchard in bloom. (Courtesy Phoenix Public Library.)

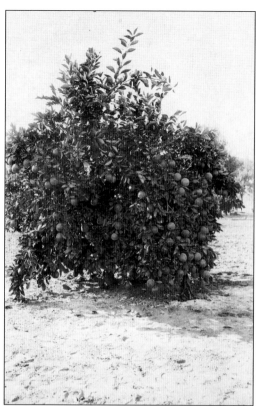

A grapefruit tree with its branches so full of fruit they are just about touching ground is pictured here. (Courtesy Phoenix Public Library.)

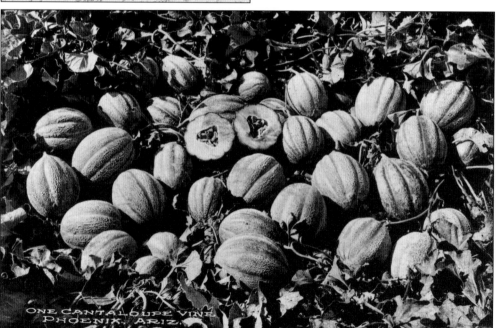

This photograph, captioned "One vine of Cantaloupe," was taken in 1910. In 1908, James McClintock wrote of the melon crops in the valley, "melons attain their maximum degree of quality—they are sugar-sweet, tender and wholly delicious." (Courtesy Phoenix Public Library.)

The first fig trees where planted in 1888, eleven miles northwest of downtown Phoenix. Above the even rows of a young fig orchard can be seen, and at right is a full-grown tree ready to be harvested. By 1908, it was reported that fig trees lined the roads around Phoenix, and figs could be had for the picking. (Both courtesy Phoenix Public Library.)

Corn was a major crop in the valley in the 1900s as was wheat. The photograph above shows a man standing with corn stalks almost to his shoulders. Wheat and barley were the chief grain crops in the valley. McClintock wrote, "Either crop will thresh 1,800 to 2,500 pounds to an acre when properly cared for." In the photograph below, a mule- or horse-drawn wagon is being loaded with wheat. Note the interesting loading machine on the right. (Both courtesy Phoenix Public Library.)

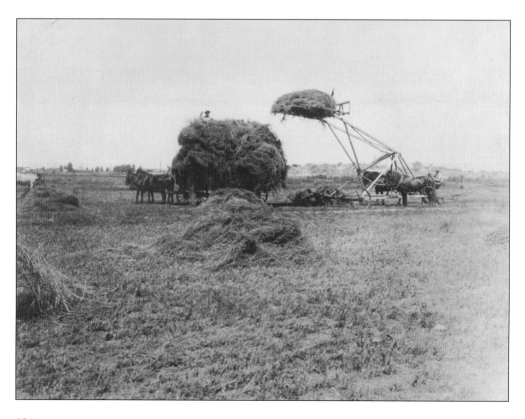

In Pastures Green. PHOENIX, Arizona.

In the winter months, the Salt River Valley was home to as many as 600,000 sheep that grazed on the green pastures and fields in the vicinity. Ranchers brought their herds south from northern Arizona, which were their summer pastures, to enjoy the warmer weather during lambing and shearing time. (Courtesy Phoenix Public Library.)

Dairy farming and cattle ranching were big business around the valley during the 1890s and 1900s. The dairy industry was an especially active business with two dairies in 1892 and four in 1905. These cattle are enjoying grazing in an alfalfa field. (Courtesy Phoenix Museum of History.)

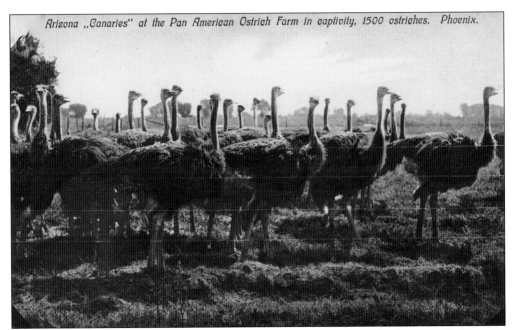

Arizona „Canaries" at the Pan American Ostrich Farm in captivity, 1500 ostriches. Phoenix.

Ostrich farms were important to the valley's economy for 25 years. The first ostrich farm was started in 1888 by M. E. Clanton. James McClintock wrote in 1908 that "there are more ostriches in the Salt River Valley than in all the rest of the Western states." In 1908, there were at least 2,000 birds on one farm and four farms throughout the valley. Ostrich feathers were clipped and sent to Eastern markets to be used for adornment on women's hats and other finery. Ostrich farmers faced ruin by 1914 when women's fashions changed, and the fancy plums were no longer used. (Both courtesy Phoenix Public Library.)

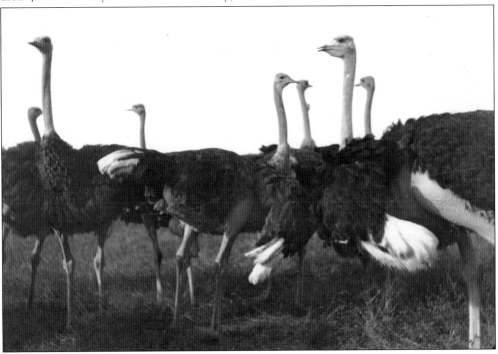

BIBLIOGRAPHY

Buchanan, James E. *Phoenix: a Chronological and Documentary History, 1865–1976*. Dobbs Ferry, NY: Oceana Publications, 1978.

Guide to the Architecture of Metro Phoenix. Compiled by Central Arizona Chapter, American Institute of Architects. Phoenix, AZ: Phoenix Publishing, 1983.

Historic Homes of Phoenix: An Architectural and Preservation Guide. Phoenix, AZ: City of Phoenix, Cooper/Roberts Architects, 1992.

James H. McClintock Manuscript Collection, Arizona Room, Phoenix Public Library. Phoenix, Arizona.

Luckingham, Bradford. *Phoenix: the History of a Southwestern Metropolis*. Tucson, AZ: University of Arizona Press, 1989.

McClintock, James H. *Arizona: Prehistoric—Aboriginal—Pioneer—Modern*. Chicago, IL: S. J. Clarke Publishing Company, 1916.

———. *Phoenix, Arizona: in the Great Salt River Valley*. Phoenix, AZ: Phoenix and Maricopa County Board of Trade, 1908.

McLaughlin, Herb and Dorothy. *Phoenix, 1870–1970*. Phoenix, AZ: Self-published, 1970.

Peplow, Edward H. *The Taming of the Salt*. Phoenix, AZ: Salt River Project, 1979.

Smith, Dean. *The Goldwaters of Arizona*. Flagstaff, AZ: Northland Press, 1986.

Ross, Margaret Wheeler. *History of the Arizona Federation of Women's Clubs and its Forerunners*. Phoenix, AZ: Arizona Federation of Women's Clubs, 1944.

Weisiger, Marsha. *Boosters, Streetcars and Bungalows*. Phoenix, AZ: Roosevelt Action Association, 1984.

DISCOVER THOUSANDS OF LOCAL HISTORY BOOKS FEATURING MILLIONS OF VINTAGE IMAGES

Arcadia Publishing, the leading local history publisher in the United States, is committed to making history accessible and meaningful through publishing books that celebrate and preserve the heritage of America's people and places.

Find more books like this at
www.arcadiapublishing.com

Search for your hometown history, your old stomping grounds, and even your favorite sports team.

Consistent with our mission to preserve history on a local level, this book was printed in South Carolina on American-made paper and manufactured entirely in the United States. Products carrying the accredited Forest Stewardship Council (FSC) label are printed on 100 percent FSC-certified paper.

MADE IN THE USA